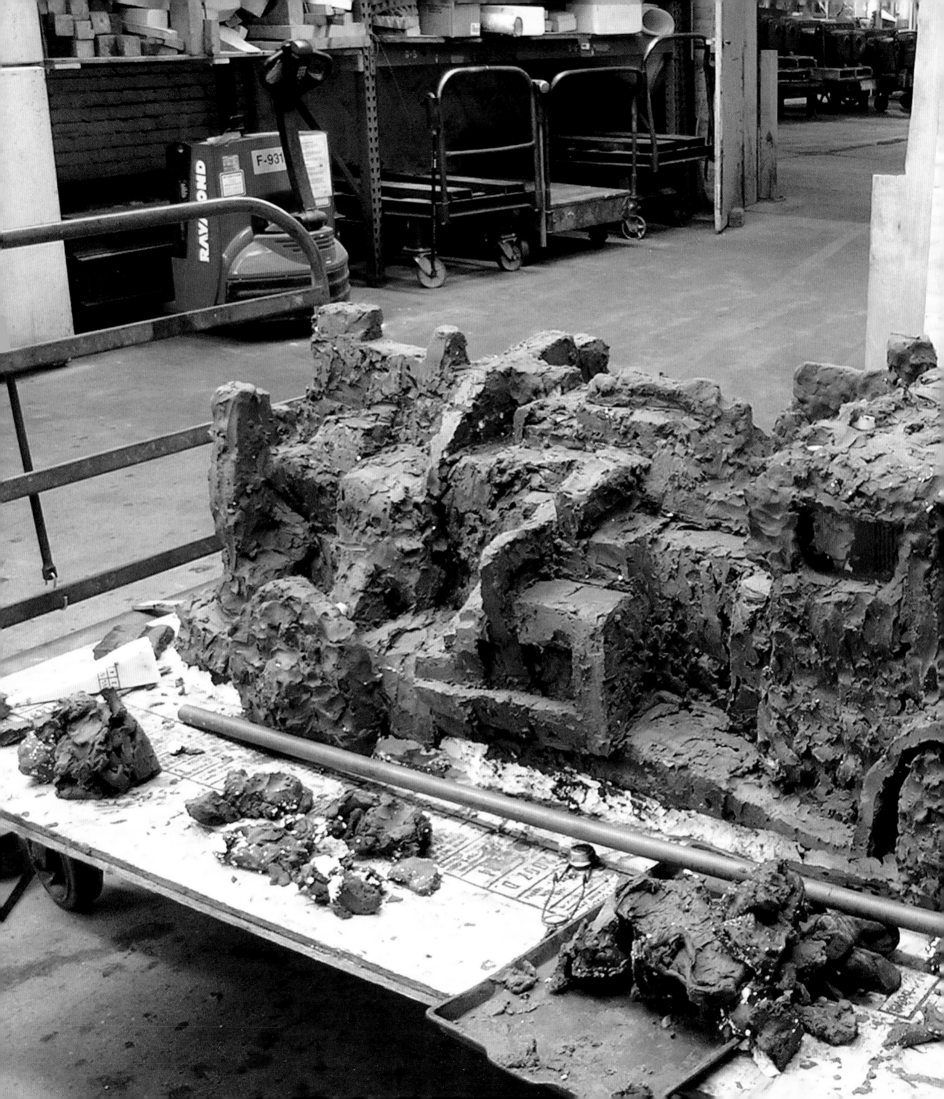

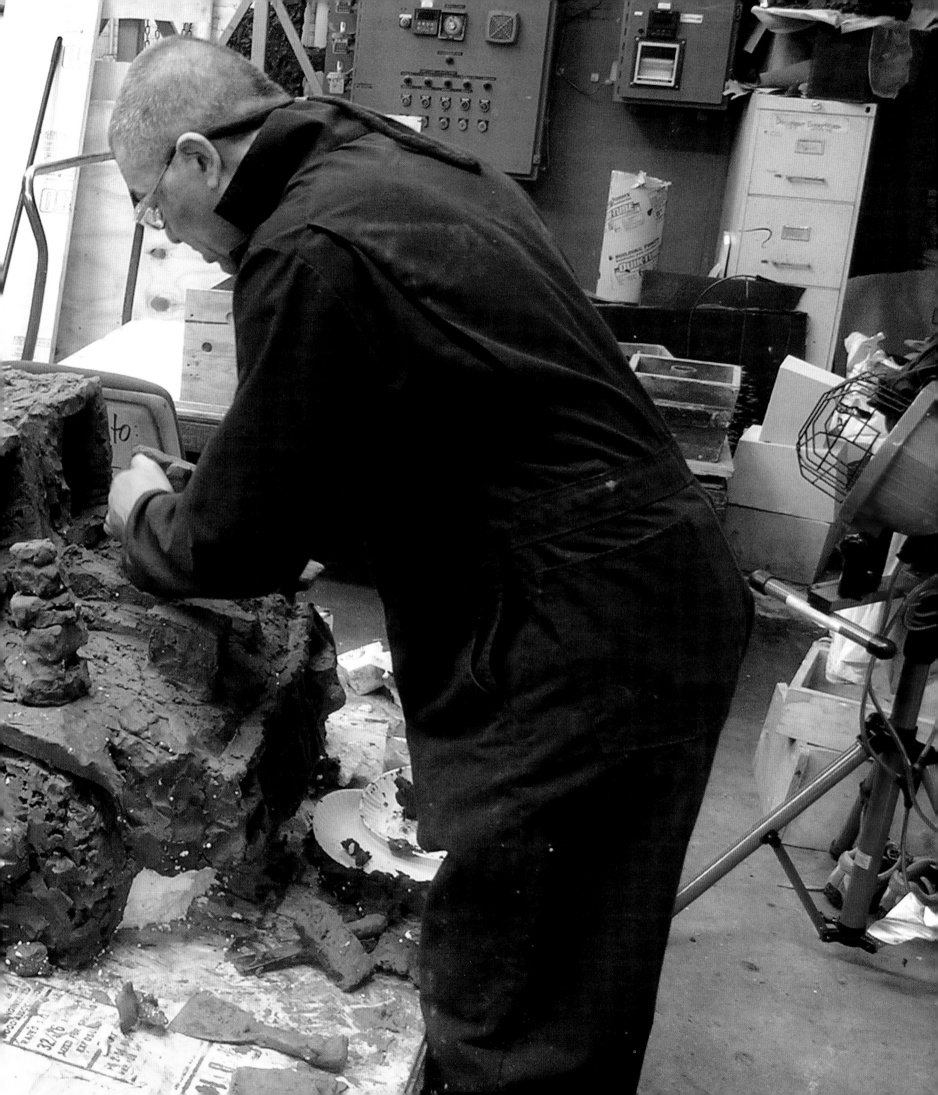

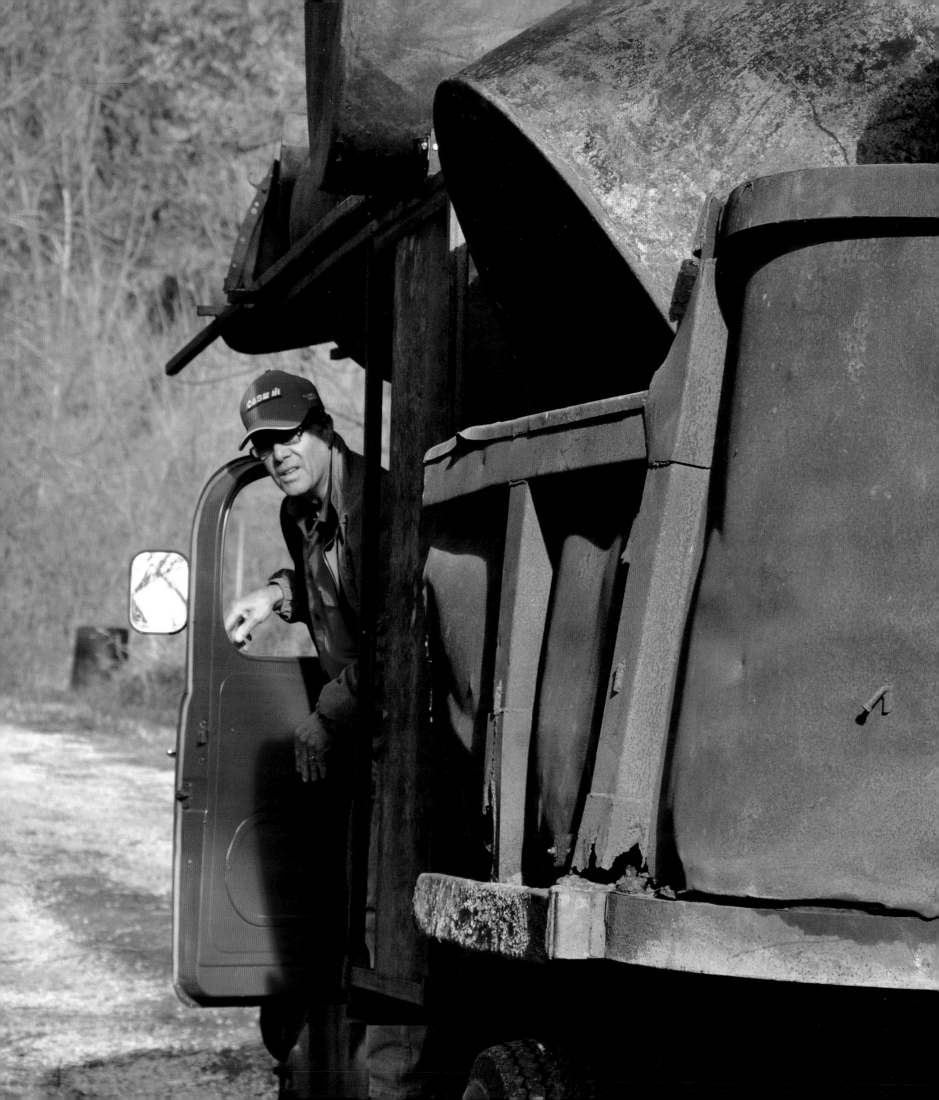

TRUCKS

Recent Works by John Himmelfarb

Essays by
Janet L. Farber
Scott Griffin
Stephen Luecking

The Artist Book Foundation
New York London Hong Kong

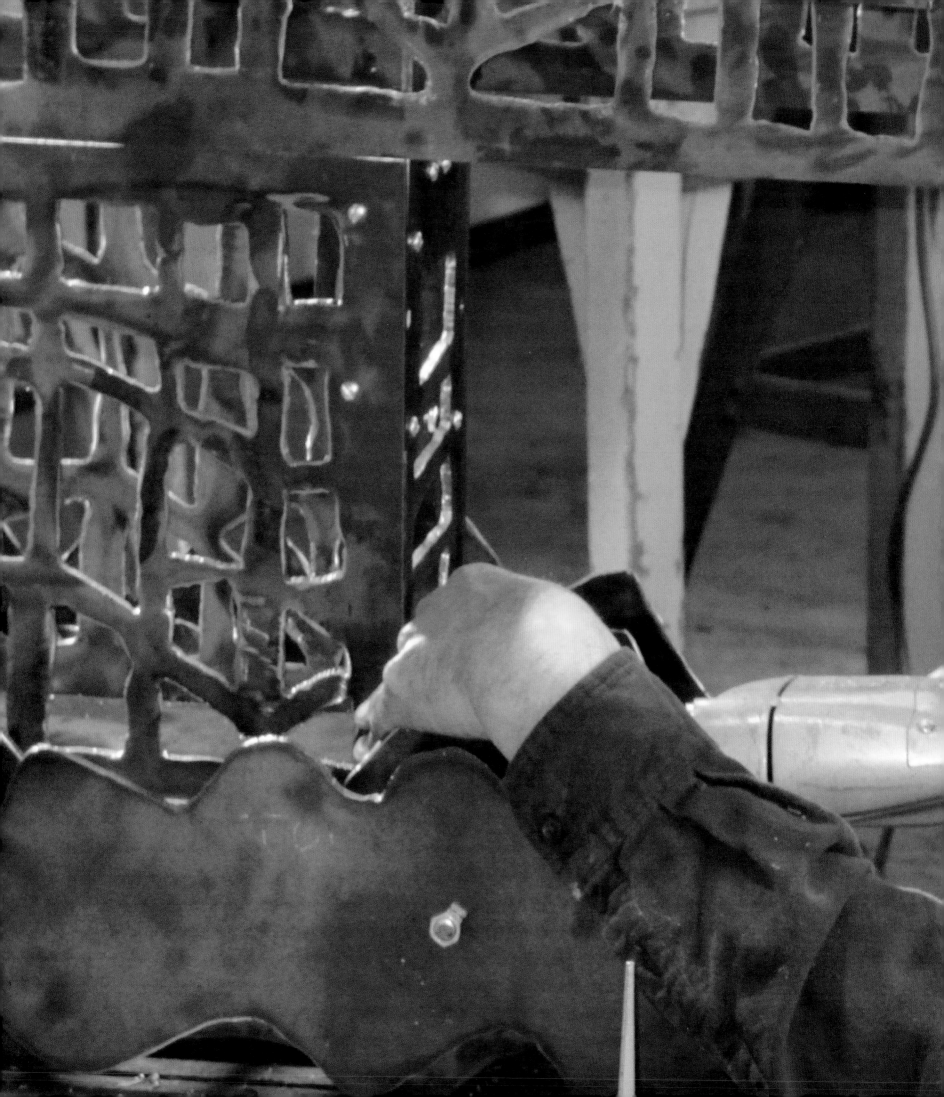

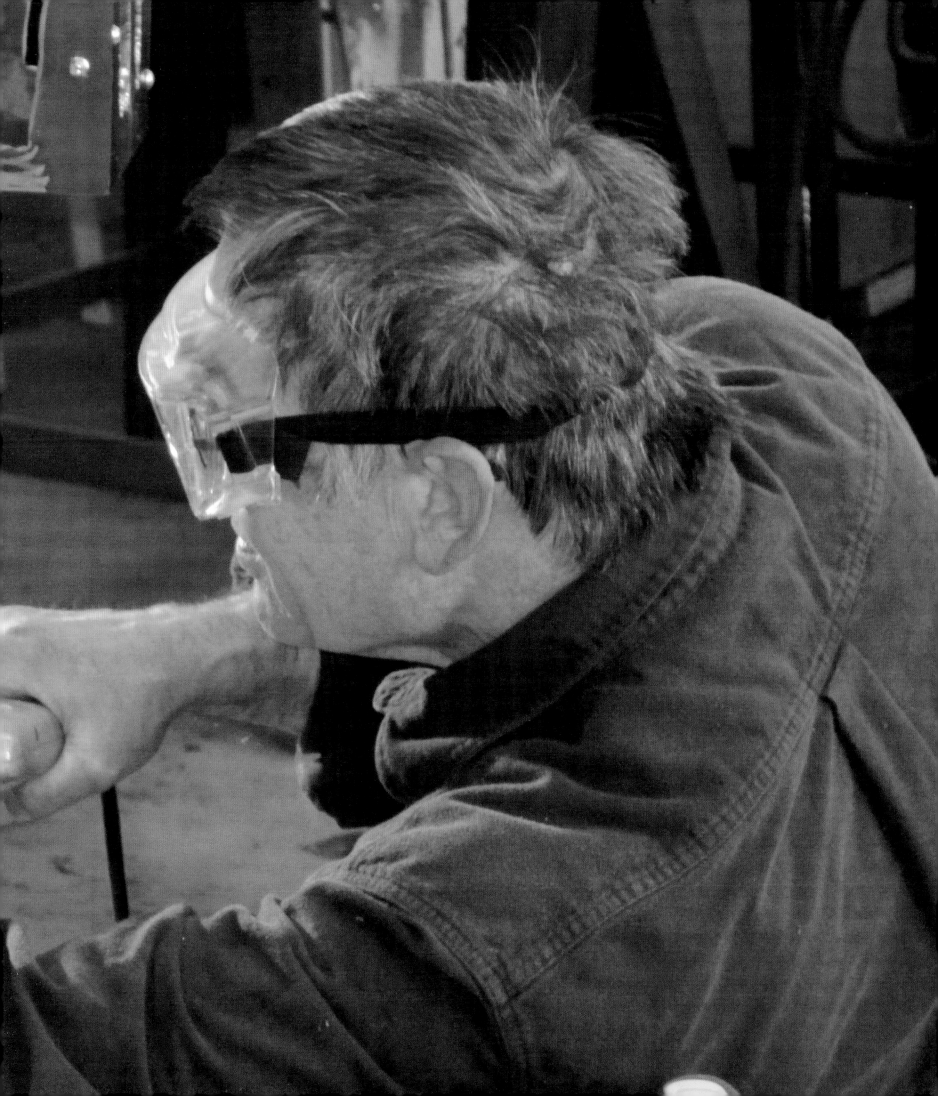

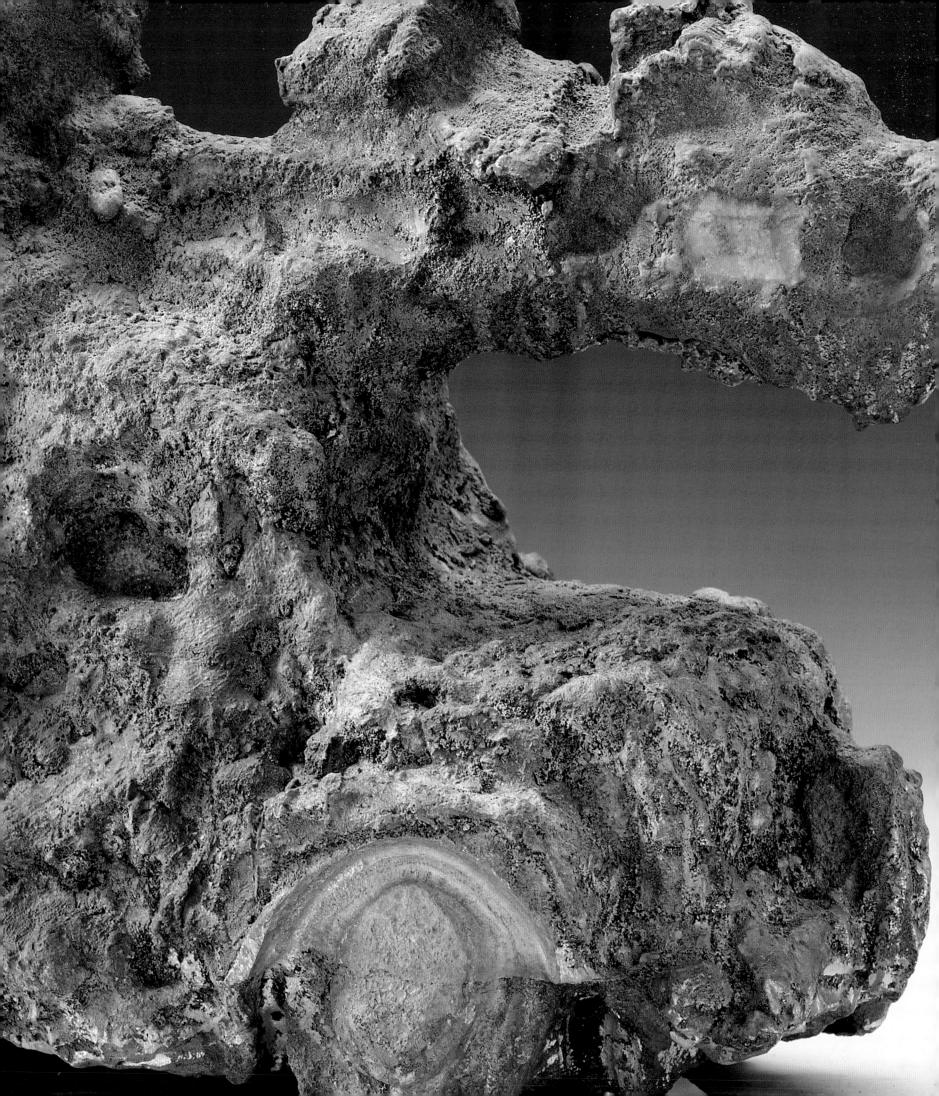

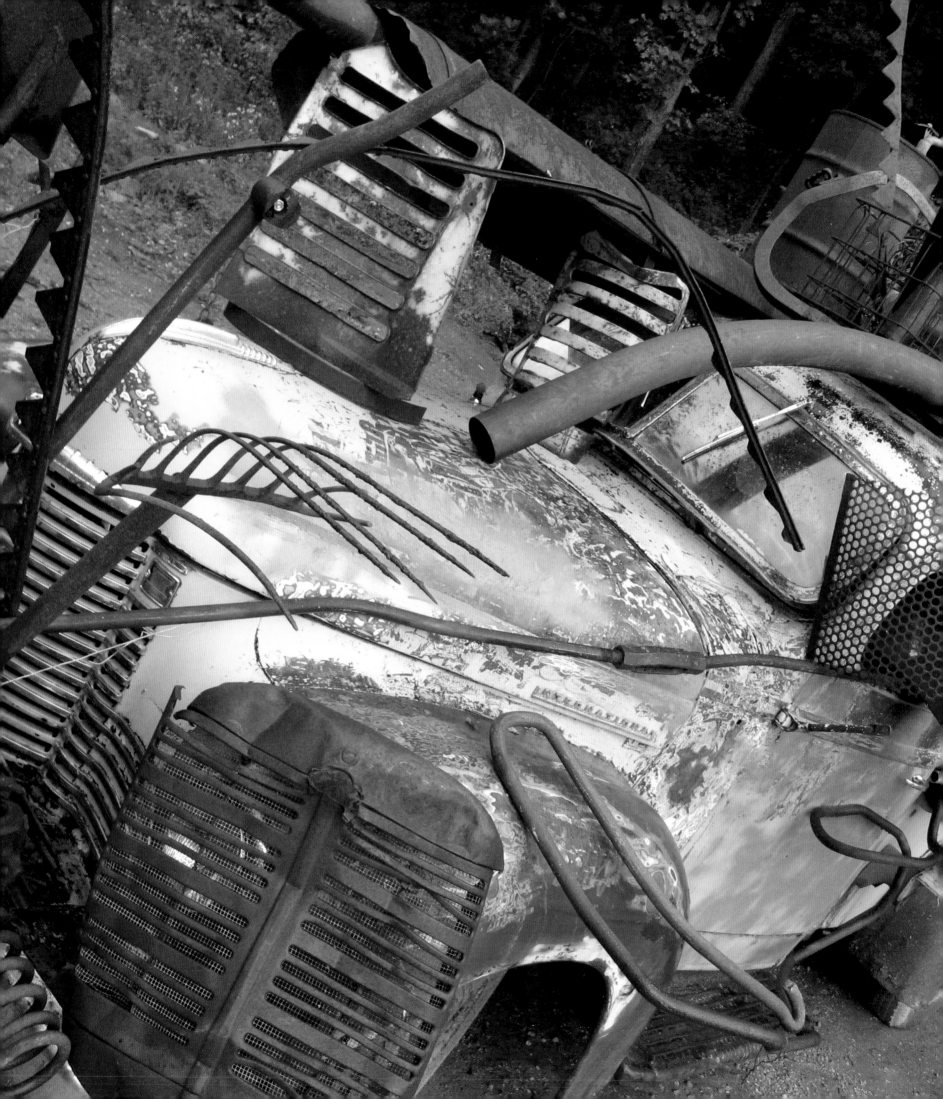

"WHY APPLES?" ASKED ADAM

John Himmelfarb

To my constant amazement, people of all backgrounds and dispositions ask me, "Why trucks?" (Dogs never ask me this, as they share my excitement.) Does anyone ask the artist of still lifes, "Why apples?"

For centuries, still lifes were held as a lesser form of art because they seemed to lack reference to intellectual concepts concerning religion, history, and philosophy. Only recently has the still life been accepted as a possible approach to high art. Just in time for my trucks.

An excerpt from my sister Susan's recent remarks (in a discussion about whether a mystery story can be literature) is germane here: "As the child of two abstract painters, I learned from the air I breathed that content only becomes art when it is given meaning by the form an artist gives it, and that this is as true for literature and music as it is for the visual arts."

My primary driver as a visual artist is to create form that is exciting visually and that suggests content ripe for interpretation through association, metaphor, and implication. I am not concerned with illustrating what we see.

While I played with toy trucks as a child, and included some in childhood drawings, trucks were not major players in my childhood art. Growing up in the woods of DuPage County, west of Chicago, I did hear, more than a mile away and late at night, the sounds of the big rigs headed for the city with cattle and other products from the west. Once in a while, having trouble getting to sleep, I would slip out of the house and walk the distance to Alternate U.S. Highway 30 so that I could see them speeding east as well as hear them up close. The romance of American agriculture, commerce, and industry was contained in these visions.

(opposite): CLOSE-UP OF *CONVERSION* DURING COMPOSITION PHASE, SPRING GREEN, WI, 2008.

Only when I became a professional artist did trucks appear as a recurring motif in my work. At that time, uncertain as to whether I could earn enough money to support myself, my plan B was to become a big rig driver. I invented the business name "Darryl Licht Transport," an imaginary cartage firm. "Transport" reflected my desire to transport people through my art, which would remain my primary occupation. "Darryl Licht" referred, perhaps, to the condition of my 1870s Chicago studio. Stationery from this enterprise is filed away somewhere.

The image of a truck appeared from time to time as my oeuvre evolved, much as it had in my father's paintings and drawings. Our mutual interest seemed to be in the visual stimulation of the colors, shapes, textures, and other elements of visual language to be found in the maw of a garbage truck, the back of a livestock hauler, and countless other complex specimens of the cartage world.

Only much later did I consider the cultural connotations, the significance of what trucks mean to us subconsciously. In the 1990s and into the twenty-first century, I executed a series of paintings called *Inland Romance.* Chiefly abstracted from the urban landscape of the Midwest, forms generated from cranes, bridges, tracks, roadways and maps, and all manner of urban ironworks, these paintings had layers of network patterns, each extending over the entire canvas.

In 2003, on a visit to the Art Institute of Chicago, I saw a painting I'd never seen by Dubuffet, one of the artists who had been most stimulating to me over the years. I do not recall its subject, but it had a soft abstract background of muted color and amorphous shapes on which was superimposed a line drawing in very liquid black paint. The graphic impact was very strong. I wanted to make a painting like that!

I immediately went back to my studio, mixed up some blues and greens (as I recalled them in the Dubuffet), and laid down a patchwork of color swatches of no particular distinction. Over that I began to draw with a liquid black paint, using a thinner brush suitable for drawing.

As usual, I had no particular image in mind. I began on the right side with my industrial forms. The result looked like a crane, and I stopped far short of covering the entire plane with this pattern. It wasn't enough, so I recommended drawing beneath the boom of the crane. The truck that emerged delighted as much as it surprised me. I felt an immediate visceral connection.

Having experienced a lifetime of art (literature, visual art, music, and theater), I have a great deal of confidence in my ability to sense when a work has resonance on many levels, and this painting, which I titled *Inland Romance: Bypass,* did (pl. 6). I felt compelled to try creating something similar again and, shortly thereafter painted *Avion* (pl. 9), a painting whose title may have been inspired by Magritte's *This Is Not a Pipe.* Not only does the word *avion* not mean "truck," the painting is a representation of something more than a truck.

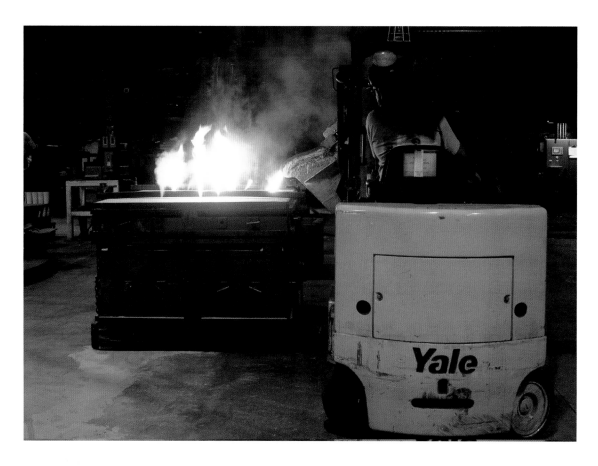

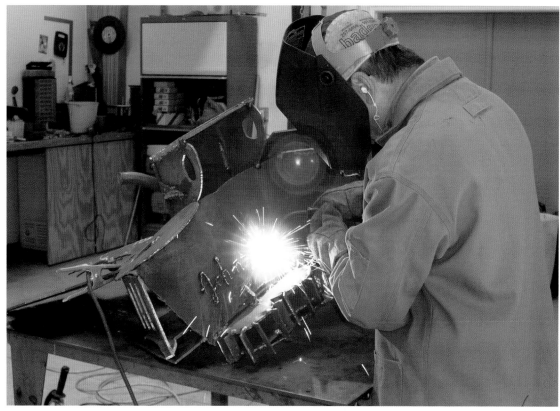

The truck works then exploded rapidly in numbers and materials as I followed this still-unexamined "hook." To me, the resonance was so clear as to need no examination. However, as these works gained increasing exposure, I was asked repeatedly to answer the question: "Why trucks?"

I explored this question from many points of view, and I found the exploration itself a satisfying endeavor, though the validity of an answer always fell short of any mathematical certainty. The exercise was similar to those I had gone through with other bodies of work that continued over a long period of time. It gave me the same kind of satisfaction I experience in thinking about why a particular novel strikes me as of great moment.

While I have talked to many individuals about these trucks and possible interpretations, I now realize that for me to tell other viewers how to interpret or understand these works is to deprive them of the personal discovery that comes from looking at art.

Now I turn the "Why trucks?" question around. I ask those who query me about my choice of subject matter, "What do *you* think about when you see these works?" Invariably, I hear, often slowly at first, a series of references both personal and universal to direct experiences, to literature, music, and to the work of other visual artists.

It is clear to me that I don't need to tell anyone anything about these pieces. The best thing I can do is to give them permission to answer their own questions. I encourage people to explore my use of visual language and the resulting form. This is where they will find answers. Ultimately, its up to each of us to answer for ourselves the questions we have about the meaning of anything, even apples and trucks.

(opposite): A BUCOLIC SCENE AT L&M SALVAGE, RICHLAND CENTER, WI, 2008

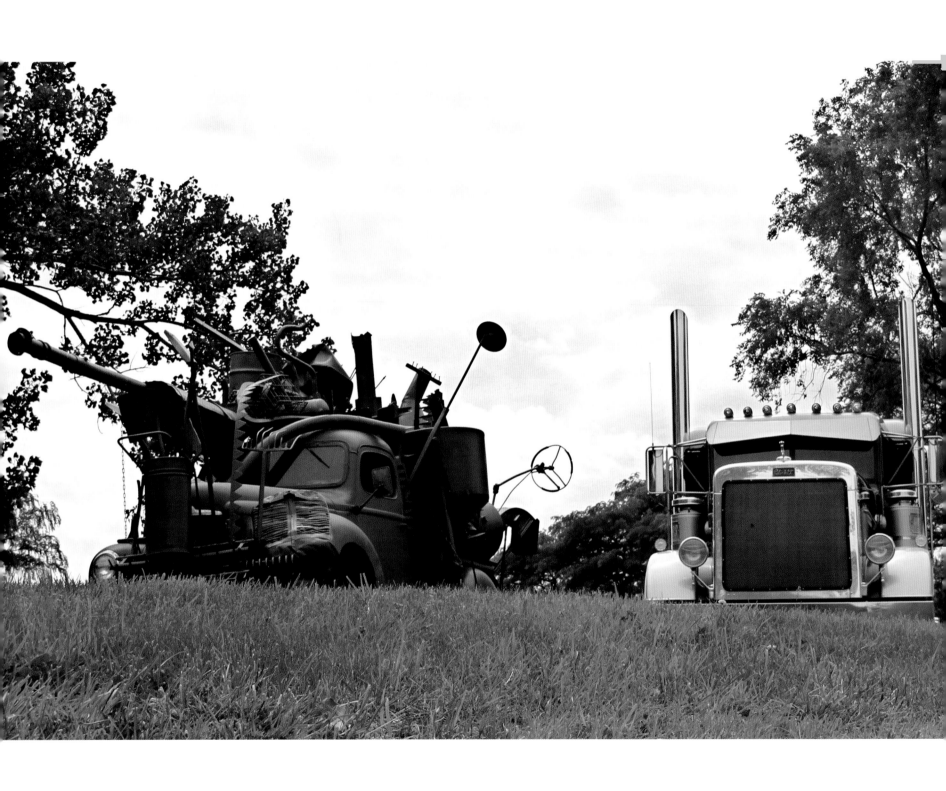

AMERICAN TRUCK

Scott Griffin

Its origins are in the chariot and the charette, and later in the caisson and the stage-coach. Driven by animals spurred on by men, these rusticated rolling conveyances of wood and iron happened to combine work with travel, bringing to the harsh realities of each a parlous sense of adventure. The modern-day version of a teamster, riding high behind the wheel of his leather-upholstered Dodge Ram or Chevy Silverado—so named by the fabulists of American advertising—might call this sort of adventure a pleasurable way of taking the long way home.

Driving down Guadalupe Street on a fine Friday evening in Austin, a modern-day teamster is much more likely to be a computer engineer or a certified public accountant than a rancher or a roughneck. Never mind that there's not so much as a hay bale to resemble a payload in the bed of his truck or that the only thing riding shotgun is a monogrammed briefcase. It should never be said that such a man's conveyance is anything less than a "work truck," because the term is so indivisible as to be sovereign, and so sovereign as to be idiomatic.

And so idiomatic as to be iconic. The American truck is a cross-cultural citizen. It passes fluidly from the medium of language to the medium of form, reaching as far as the medium of sculpture, but sculpture always as a mobile, playing across the variegated American landscape, like the daydreams of Sam Shepard or David Smith. The American truck

(opposite): A PETERBILT ADMIRING *CONVERSION*, 2012.

plays whichever way the wind blows or whatever way the road leads. It does this especially well at the intersection of art and commerce, where, for example, Madison Avenue and Austin, Texas, meet. At these kinds of crossroads, the American truck has always been idling and at the ready, drawing stares of admiration from any odd person you might care to pick out from a police line-up—aesthete or executive, city slicker or country boy. After all, the American truck is Big Man on Campus without having read a single book; it almost always gets the girl on or off camera; it looks equally smashing parked in front of the Park Plaza Hotel or tooling about the Dakota badlands; and it takes great care to keep its relationship to the American motorcycle strictly avuncular.

Turning his truck away from the honky-tonks of downtown Austin toward Highway 1 and the rocky undulations of the Texas Hill Country, it's unlikely that our college-educated cowboy cares much to learn that the words *travel* and *work* are close siblings, derived, in turn, from *travail* and then *travailler*—French for "work." No matter. Any such information would be quickly drowned out by the ambience outside his cab and the serenity within it. The stark hardscrabble beauty of central Texas passes by under the westering sun, relieving his mind of thought. Through his open window a roadside sachet of dried wildflowers and weeds scents the air, and on the radio—turned up loud—Lyle Lovett somehow is singing "South Texas Girl" more sweetly than he has ever done before from the self-same recording. This teamster/cowboy/knight errant—call him what you will—is versed in a different armature of words, ones he began to acquire the day he tossed away his Tonka truck and began to aspire to a real one.

He might have heard them first from his father: Four-on-the-floor and three-on-the tree. Fifth wheel and jake brake. Tailgate and ball hitch. Up shift and overdrive.

But holding the center of them all is the one word with enough gravitas to really capture his imagination, the matrix where his heart and mind collide, the word which still thrills him as he pushes his truck up a long incline and the big V-8 engine under the hood reports to the demand of his throttle like a Minuteman and his rifle: *Horsepower.*

To him the word has taken on an almost mythical proportion, in part because he has never really known its meaning. He knows only what the dealer told him, which is exactly what the dealer sold him: a truck that has horsepower, the power of horses.

And so, by the right of ownership, has he.

Up and down the rocky undulations of Highway 1, he receives the transmission of horsepower from the steering wheel to his hands like a benediction. The rigs of men who really are ranchers and roughnecks go by, hauling heavy flatbeds of galvanized pipe or pulling elongated goosenecks loaded with livestock. In between go trucks outfitted for welders, trucks set up for linemen. Trucks with outriggers, trucks with booms. He passes round a jalopy on bald tires piled high with an elaborate construct of scrap metal, driven by a weathered old mendicant. This is a two-lane road, and from a half-mile distant he discerns the pronounced snout and the bug-eyed lights of an 18-wheeler Peterbilt barreling his way. The big rig rushes by so fast and close that the chassis of his own truck shudders and sways in the turbulence. But among this convoy of motleys he feels not only that he is in good company but even more fundamentally that he is a good man. It is a sense of strength and

resourcefulness, virility and certitude, drawn from riding high with all that horsepower at his hands. By virtue of his truck and all his truck can—or could—do if called upon, he is a man most utilitarian, a man most esteemed. From his wild cherry taillights to halogen headlamps he is his own Fourth of July parade.

At dark he parks his truck in the driveway. Stepping down from the running board he negotiates a welter of toys scattered on the drive. The evidence at hand tells him his two sons have made a construction site of his wife's Rhododendron bed, and that inside he will find trouble on the order of melted ice cream.

He cannot recall where he heard it, but as he navigates the toys underfoot, a phrase repeats in his head:

"The child is father of the man. The child is father of the man."

Maybe it's a jingle or a tagline that his ear gleaned from some advertisement for pickup trucks.

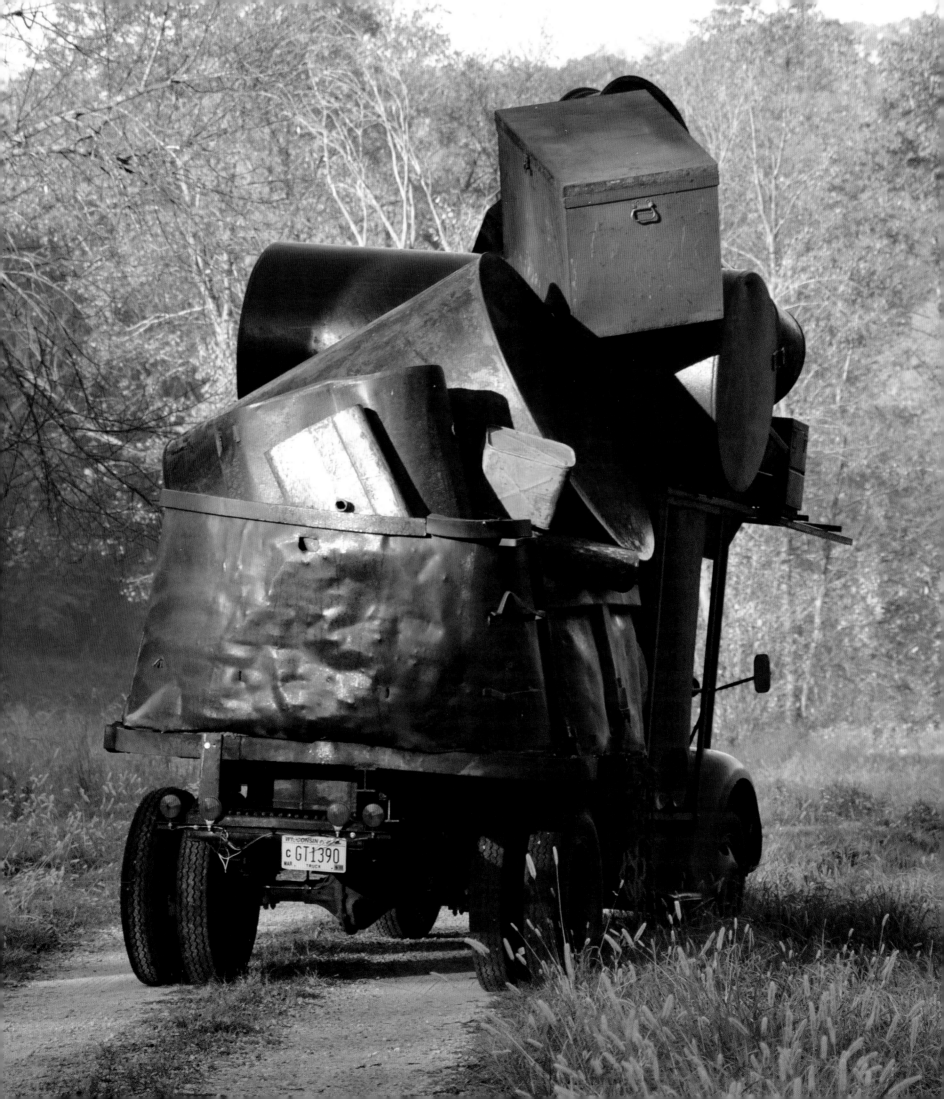

JOHN HIMMELFARB AND THE PHYSIOGNOMY OF TRUCKS

Stephen Luecking

Not just any truck is a candidate for portrayal in a painting by John Himmelfarb. There are preferences. First, it's best if the bed rigidly attaches to its body. So, semis roll aside. Second, its bed should be open and separate from the cab. So, vans roll to the back of the line. Finally, selection favors those that have, piled on or affixed to the bed, numerous machines, devices, gadgets, gimcracks, whatzits, thingamabobs, doohickeys, widgets, and the like. So, tow trucks and sewer vacuums make the cut; as do crane trucks and garbage trucks. Even the trucks of scavengers plying the alley for recyclable metal objects merit profiles in the artist's work. Trucks whose left profile is their best and whose body type is of an age comparable to the artist's receive preference.

That the particular function of the truck might remain a mystery is often of no concern. The character of the truck, however, matters greatly. The presumption is that the form of the truck reveals much of its personality, of the workings of its mind, or, more precisely, that of its unknown owner/driver. With titles like *Forbearance* (2009), *Courage* (2007), *Faith* (2006), *Hope* (2006), and *Chastity* (2006), this artist assigns virtuous attributes to the trucks. To the extent that the symbiosis of truck and driver constitutes a character and that this can be read in the painted, drawn, or sculpted form of the truck, Himmelfarb is a physiognomist of the truck.

Physiognomy—from the Greek *physis* for nature and *gnomon* for judge—is the centuries-old science of reading a person's character in the physical attributes of his or her face. Aristotle wrote the first known treatise on physiognomy, in which he assigned, for

(opposite): *GALATEA* WITH MORNING DEW, SPRING GREEN, WI, 2010.

example, "swinish" character to those with bulbous noses. Physiognomy held great interest for artists of the late Medieval and the early Renaissance. From its application to portray the sins and sinners in morality broadsides of the former, it evolved into a tool for crafting psychological portraiture.

Today, this "science" has gone the way of astrology and alchemy. Science of the eighteen and nineteenth centuries, however, added to it the panache of technological sophistication with such studies as the electrical stimulation of facial muscles or the measurement of skulls to determine formations indicative of criminal behavior. It thus became the preferred science for supporting class structure and racism.

In 1528, the year of his death, the German artist and publisher Albrecht Dürer published his text *Vier Bücher von Menschlicher Proportion (Four Books of Human Proportion)*, in which he steered the methodology of physiognomy away from character reading to a mathematical means of generating endless forms of the human face. Dürer did this by adapting the physiognomist's process of using a grid to measure proportions between facial features and shifting the lines of the grid to change the proportional relationships and create new faces. A quick look at the mathematics demonstrates the possible number of faces that could be so generated. For example, if the change in position of the key features were limited to a fixed unit horizontally or vertically or diagonally, then each feature could hold nine positions on the face. Dürer assigned over eighteen key points on the head to grid intersections.

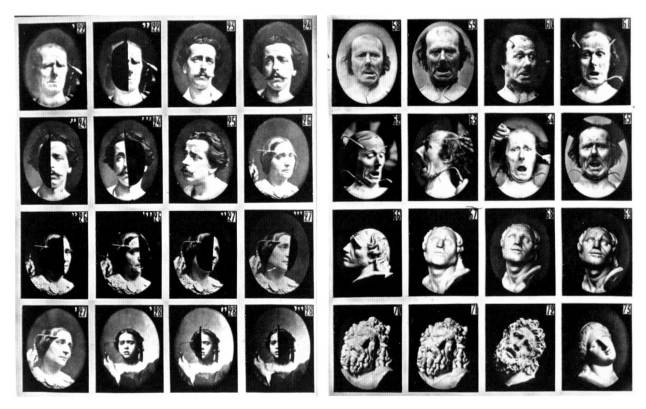

DUCHENNE DE BOULONGE, ELECTRO-PHYSIOLOGIE PHOTOGRAPHIQUE, PLATES 5 AND 7,
FROM *THE MECHANISM OF HUMAN PHYSIOGNOMY*, 1862.

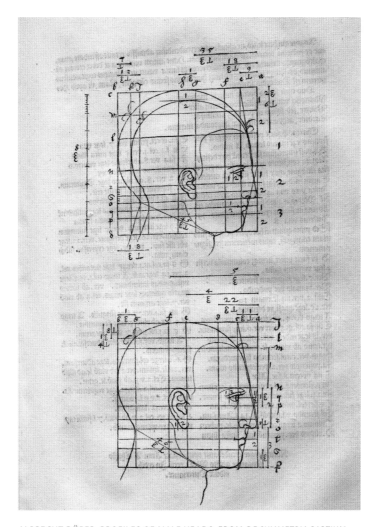

ALBRECHT DÜRER, PROFILES OF MALE HEADS, FROM *DE SYMMETRIA PARTIUM,
IN RECTIS FORMIS HUMANORUM CORPORUM NUREMBERG*, 1532.

The permutation of nine potential locations for eighteen points is given as 9^{18} or 15,009,463,529,699,121 or over fifteen quintillion. This suggests that there are enough faces to go around for all the people who have ever lived or will ever live.

It also suggests that Himmelfarb will not run out of trucks to paint anytime soon. This is true even though he has been doing so for ten years now with several hundred works under his belt. Unlike Dürer's invention, there is nothing mathematical about Himmelfarb's approach: his permutations are improvisational, not algorithmic. However, that approach is at least as productive and far less mechanical. Improvisation honors creativity over rote execution. It yields discovery, as it allows the introduction of fresh parameters and the elimination of others.

Physiognomy is spurious science because innate facial structure has no causal link to its owner's inner state. It relies on the observer's own aesthetic or emotional responses rather than objective fact. It is more the stuff of caricature than of character. The portrait artist, however, must use appearance, the visual information of the painting, to record the

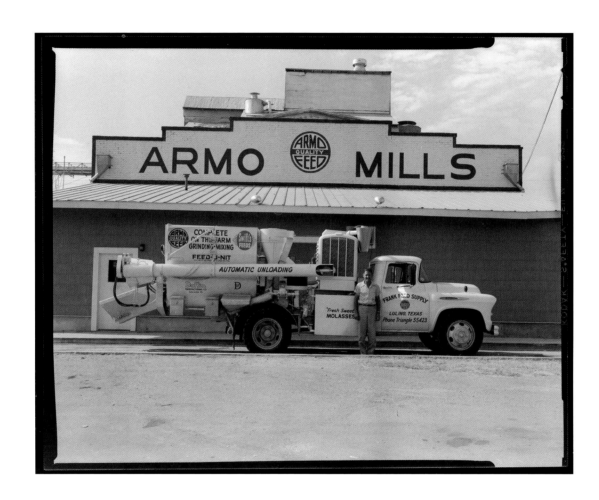

HARRY ANNAS, *UNTITLED* (MAN STANDING IN FRONT OF ARMO MILLS TRUCK FEED GRINDER), C. 1955.

consequences of behavior, experience, and environment—the real indices of character. In this spirit, the wheels of a Himmelfarb truck might splay like the legs of an aged mule or seem on the verge of spilling over.

The visible effects of the experiences through which people live might be looked upon as acquired physiognomy. Nowhere is this more to the behest of the portraitist than in those effects on the skin, the interface between the inner and outer environment of the body. From Domenico Ghirlandaio's *Portrait of an Old Man and His Son* (1480) to Rembrandt's depictions of his elderly self to the faces of Andrew Wyeth's Maine neighbors, meticulous rendering of subjects' skin has been a hallmark of psychological portraiture. For modern artists like Vincent Van Gogh or Emile Nolde or Henri Matisse, as for Himmelfarb, the physical character of paint replaces the detailed imaging of skin as an expressive tool.

Himmelfarb's depiction of the truck can never achieve actual portraiture, but under the artist's hand it can elicit the identity of a character, the portrayal of a human type whose nature and condition the viewer instinctively recognizes. Nevertheless, it makes sense to question the conceit of conferring notions like character on a truck. To a large degree, character is an attribute earned by a person but assigned by others and, as such, has a social as well as a personal dimension. This applies to a person, yes, but to a truck?

Part of the answer may lie in the case related by the son of a small town miller in rural southern Illinois. The boy's father, along with his brother-in-law, ran a feed mill servicing area farmers. In 1960 they added a grinding truck to bring their services to the farms. The truck was a complicated affair with a hammer mill for grinding, augers to transfer the grain to a huge circular mixer, and an apparatus for adding molasses to sweeten the mix. Various chutes provided means for moving grain and for bagging the feed after it was mixed. All this was mounted on an International Harvester truck frame.

The truck turned into something more than a business venture. It enabled the father to go out on jobs while his brother-in-law managed the mill. For all practical purposes, the truck was his, and he asserted this by parking it next to his house and not at the mill. For the adolescent son, it was the ever-present means of the family's livelihood, referenced in almost affectionate tones.

It served, too, in the teenager's bonding with his father. In farming communities, such bonding occurred when sons attained the strength to join their fathers in heavy labor. The son aided his father as he made his rounds from farm to farm. One memory of those rounds in particular stood out:

The grinding truck pulls up a farm lane as three yard-dogs rush to challenge the lumbering intruder. The boy jumps out to help the farmer pen the dogs while his father maneuvers the truck into position next to the barn. The boy sees the truck, stark white against the red barn—ungainly to some, magnificent to him. He notes that his father has stepped back from the truck, pausing for a beat to look it over. As the boy remembers it, the stern man's face beamed with pride.

The recognition of such instances, more than the trucks, is what John Himmelfarb portrays.

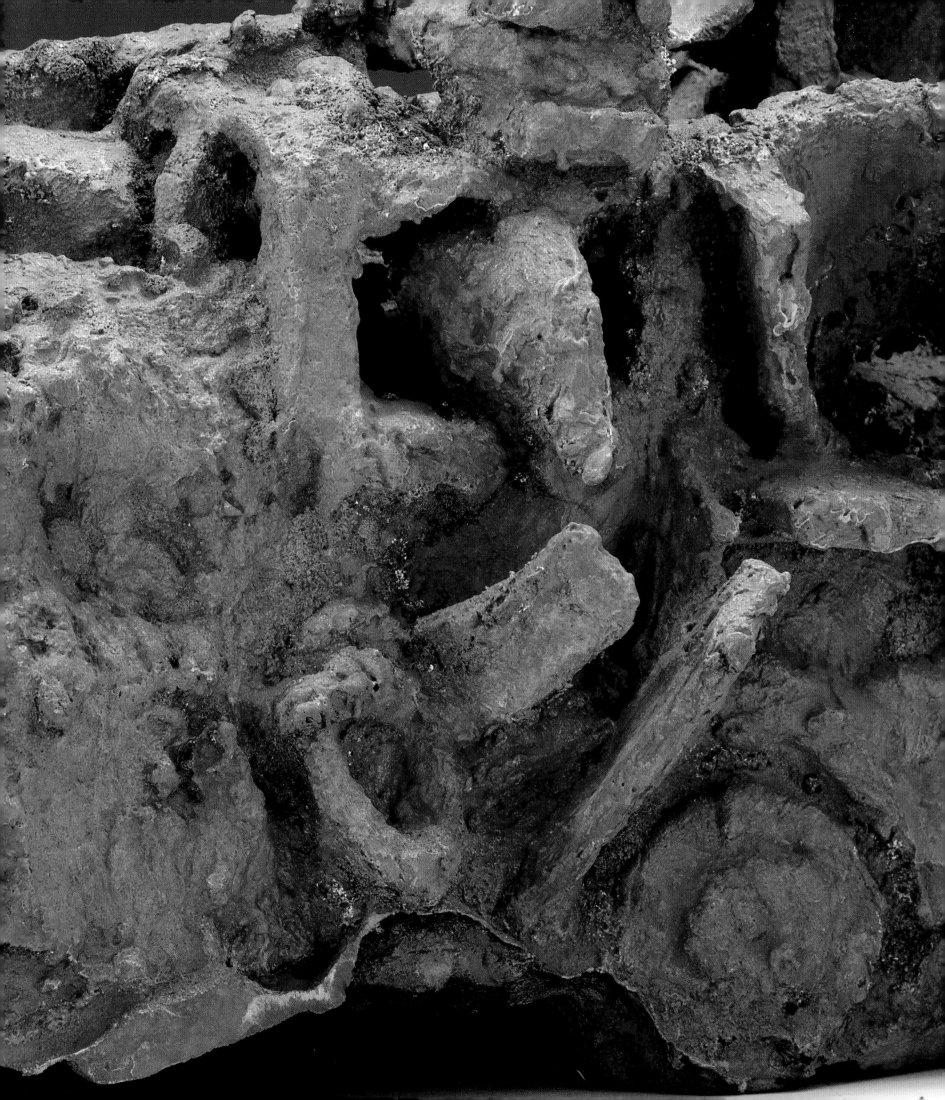

TRUCK ROUTE: THE RECENT ODYSSEY OF ARTIST JOHN HIMMELFARB

Janet L. Farber

An artist's career is a journey. It takes place over time, in any number of physical, aesthetic, and motivational spaces. It is most often traced through the development of an individual's approach to concept and content, to medium and method. Like sleuths, those following its path look for clues of continuity, relishing works that tell us a little about their past while anticipating future directions. Fortunately, John Himmelfarb has hopped on a truck for the most recent part of his personal odyssey and left tire tracks behind.

Looking at the stylistic trajectory of Himmelfarb's creative life, we encounter an artist intrigued with the good fortune of being born in 1946, with the modern era nearly complete in rear view. There he found a rich heritage of fearless experimentation: The sun-filled *plein-airisme* of the impressionists. The unblended color of the pointillists. The gaudy non-natural-istic pigments of the fauves. The shattered picture planes and bricolage of the cubists. The dynamics of futurism and its metropolitan fervor. The alliance of abstraction and modern materials in constructivism. The evocative dreams and subconscious thought in surreal-ism. The emphatically unschooled, child-inspired art of CoBrA and *art brut.* The rejection of traditional field/ground relationships and the limitless nonobjectivity of abstract expres-sionism. For Himmelfarb, this legacy was not one to dismiss or flee from but to mine like a treasure trove for its relevance and possibilities.

The result has been an oeuvre that moves easily between abstraction and figura-tion, between subject and symbol, between the general and the specific, between figure and ground. Himmelfarb's own approach to modernism is not that of the methodical scholar or devoted connoisseur, having never studied art history formally, but of the

(opposite, detail): *BIRD IN HAND*, 2007

enlightened traveler whose encounters with the works of past masters—in museums, galleries, and publications—registers emotionally and viscerally. To shrug them off would be to deny an inherited visual culture that is part of his artistic genetic code.

Himmelfarb explores tensions between past and present in his art, with a kind of retro-modernist vibe developed across multiyear cycles of thematic inquiry. Among these are land- and cityscapes, letterform and map works, narrative puzzle pieces and figurative subjects. He employs forms ancient and contemporary, expressing emotions that are personal and shared, and reveling in the possibilities of mark-making. He also moves fluidly through mediums, including painting, lithography, etching, silkscreen, and drawing in ink or pencil, with a decided preference for linear techniques. Over the last ten years in particular, the artist has focused his studio practice on the many directions he can take utilizing the isolated image of the truck.

Himmelfarb's muse manifests itself in distinctive forms. His trucks are usually vintage, somewhere between timeworn and timeless. They are not precise renderings of specific machines, but are broadly conceived. They reveal power through the size of their cargo or heft of their machinery. They are thoroughly utilitarian, doing the tough jobs of logging, digging, mixing, lifting, hauling, and towing. They are part of an apparatus of life, but whether their job is to build something up or tear it down is left intentionally ambiguous.

Most importantly, the trucks are imbued with character. They are lively and anthropomorphic, and Himmelfarb often titles his works according to the attitude a finished composition seems to display. They come from a memory bank imprinted with childhood stories and days spent with sandbox toys. They embody skills of building and creating. They also reflect the cycle of items consumed and discarded, of burdens that are material and psychological.

As subjects drawn from the iconic history of American transportation, Himmelfarb's trucks are categorically unusual. They have a work ethic, but are not pickups—those idiomatic, horsepower-laden extensions of cowboy mythos and frontier spirit. They do not come from classic auto territory; they do not exude muscle or speed or sex. They are a bit baroque yet have no kin among art cars, magic buses, embellished food trucks, or tricked-out lowriders. They have rhythm and motion, but they are not racecars or sleek fleet semis. Himmelfarb's trucks are clunky and work-worn for sure, but still laboring hard.

As art objects, these truck-themed works are also singular among those artists who have incorporated vehicles into their métier. There is no pop-minded conflation of midcentury consumerism and car culture (James Rosenquist). Its anthropomorphism is divined through the truck image rather than using it as a conceit for polished photo-realistic formalism (Robert Bechtle). The mood is energetic and often light, not existential (Ed Kienholz) or otherworldly (Peter Cain). Himmelfarb's closest connection in this vein is with the sculpture of John Chamberlain, who found a joy in the colorful, twisted metal of auto bodies, fins and fenders, adapting his rescued materials into exuberant, writhing abstractions like bouquets of brushstrokes.

More fitting comparisons may be found among artists plying other themes, especially those for whom humor is an instrument for broad description. Himmelfarb often mentions a kinship he feels with the work of Philip Guston, whose comics-styled paintings featured

wry and at times cynical images inspired by the prevailing social climate. Carroll Dunham works in a similar graphic spirit where modernism meets Sunday cartoons, creating curious narratives inhabited by fetishized images of men and women. Yet, the tenor of Himmelfarb's art tends to be gentler, having something in common with the exaggerated cornpone of Red Grooms's Americana. In many ways, his nearest ally may be Joe Zucker, whose 1970s history paintings of Eli Whitney's cotton gin or paddle-wheel boats were filled with a peculiar postcard charm while, with their quirky, paint-soaked cotton ball construction, taking full aim at the methods and rhetoric of contemporary abstraction. In the comfortable and natural appeal of the truck, Himmelfarb found the perfect mechanism with which to shift through changing gears of content, expression, and design.

The truck motif crept into Himmelfarb's early work in a gradual, unintentional way. Then, as now, the artist preferred to fill his planar space with an accumulation of images and forms, an affinity he ascribes in part to the scattered aggregations in the bright, cosmic *Pedazos del Mundo* paintings of Robert Neuman, an instructor of his at Harvard. Compared to Himmelfarb's current emphasis on the formal possibilities generated by a single figure, these earlier works were busy and expansive. The urban-themed *Crane Mountain* (1971, pl. 1) depicts an electromagnetic crane dwarfed by what the artist calls "a landfill gone wild." Similarly, trucks and equipment appeared along with bridges, train tracks, and other components of transportation hubbub as aspects of teeming city life that filled every corner of many compositions of the 1970s. As evidenced in the aerial views of such works as *Filming of Sunny Days* (1974, pl. 2), Himmelfarb's approach read like an automatic or freely associative form of futurism or purism, celebrating the vibrancy and fast pace of metropolitan life in the new industrial age.

Another precedent might be found in Himmelfarb's series of *Boatman* images (pl. 3), realized in black-and-white paintings and prints in 1982. In these scenes, an overladen vessel is adrift in choppy waters, its towering cargo threatening to swamp the small craft. It and its helmsman are truly "at sea," endangered by the paraphernalia he persists in carrying with him through life's voyage. These scenes are delightful updates of the Northern Renaissance theme of the "ship of fools," as codified by Albrecht Dürer and Hieronymus Bosch, widely understood as satiric allegories of human folly, of souls adrift in search of a fool's paradise. With perhaps a twentieth-century overlay of materialistic "can't take it with you" values, Himmelfarb has shifted the compositional accumulations in his works to the suggestion of portable burdens that later transpose into the lumbering freight of his haulers.

Many such motifs resurfaced in Himmelfarb's decade-long *Inland Romance* series, begun in the mid 1990s. These paintings, prints, and drawings revolved especially around the built environment of Chicago, with its traffic, skyline, density, and constant hum. These works are more compact, stripped of excess detail in favor of greater abstraction achieved through the bold, defining outline of strong shapes. At the time, Himmelfarb was mindful of his interest in Joan Miró, a remnant of his 1994 trip to Gallifa, Spain, site of the surrealist's late pursuits in ceramics, and was favoring as well the naive expressionism of Pierre Alechinsky and Jean Dubuffet. *City Circuits* (1998, pl. 4) reads as a simple

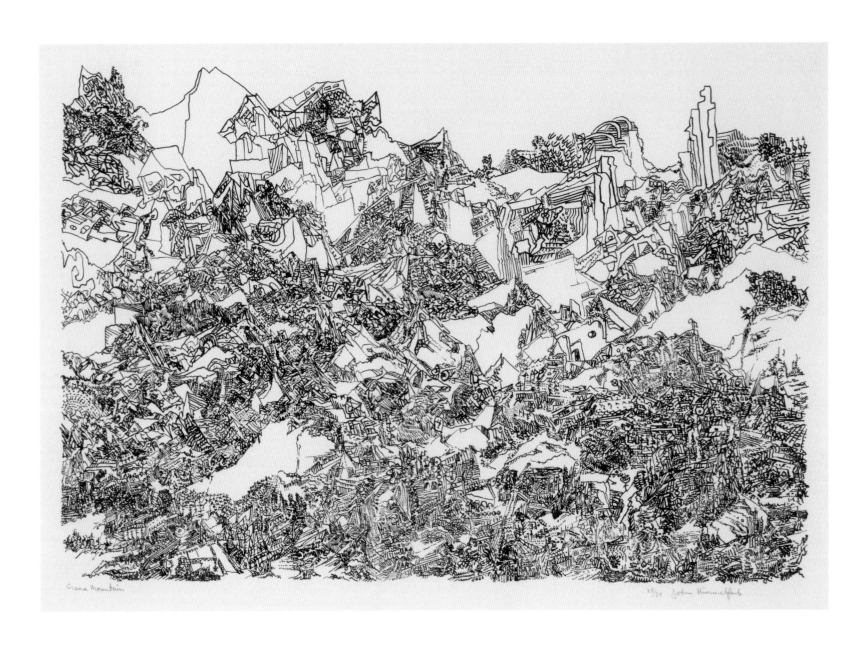

1. *CRANE MOUNTAIN*, 1971, LITHOGRAPH, 15 x 20 IN.

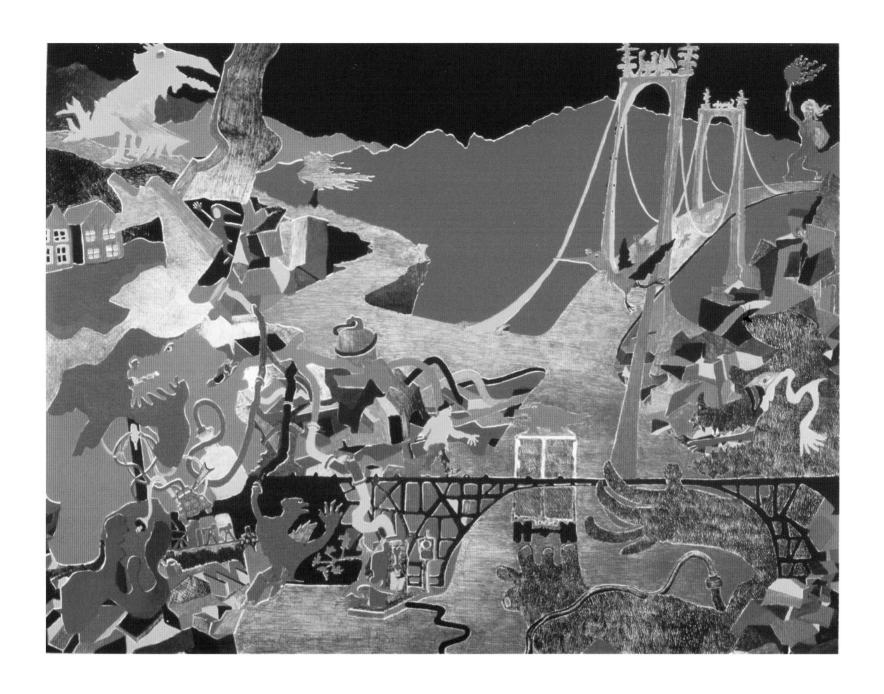

2. *FILMING OF SUNNY DAYS*, 1974, LITHOGRAPH, 30 x 40 IN.

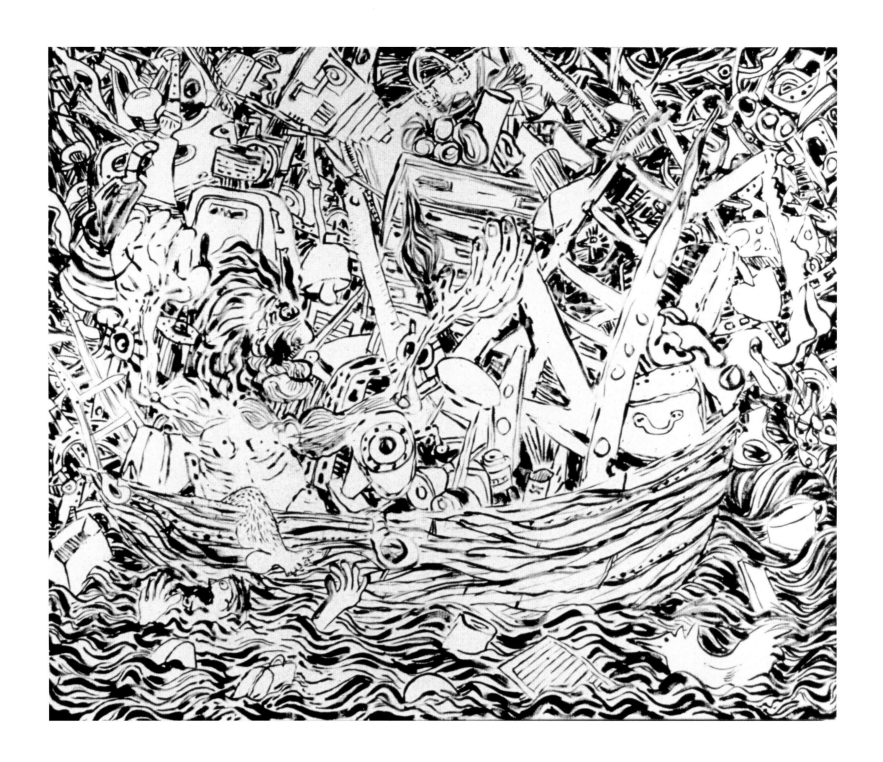

3. *RIDING HIGH*, 1982, ACRYLIC ON RAW CANVAS, 48 X 58 IN.

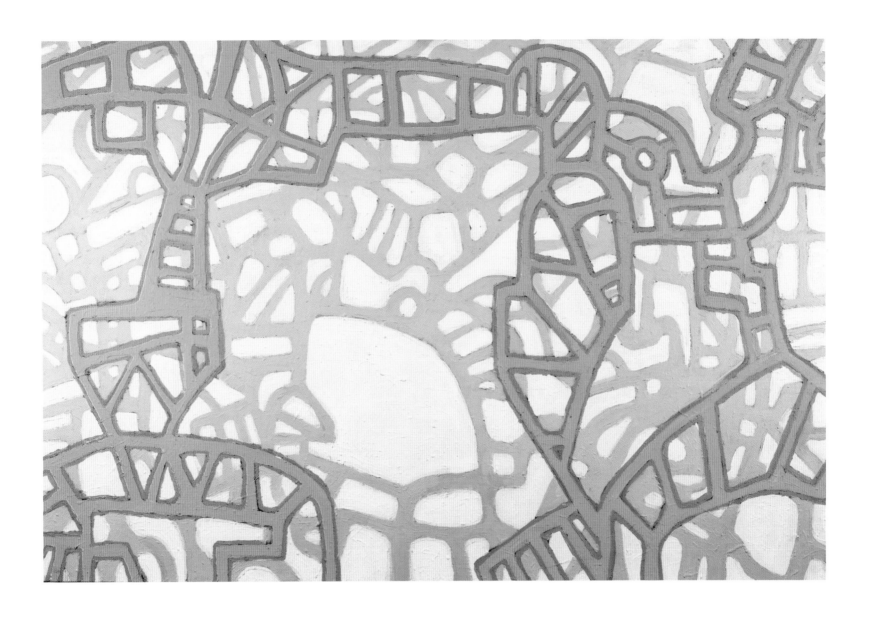

4. *INLAND ROMANCE: CITY CIRCUITS*, 1998, ACRYLIC ON CANVAS, 30 x 45 IN.

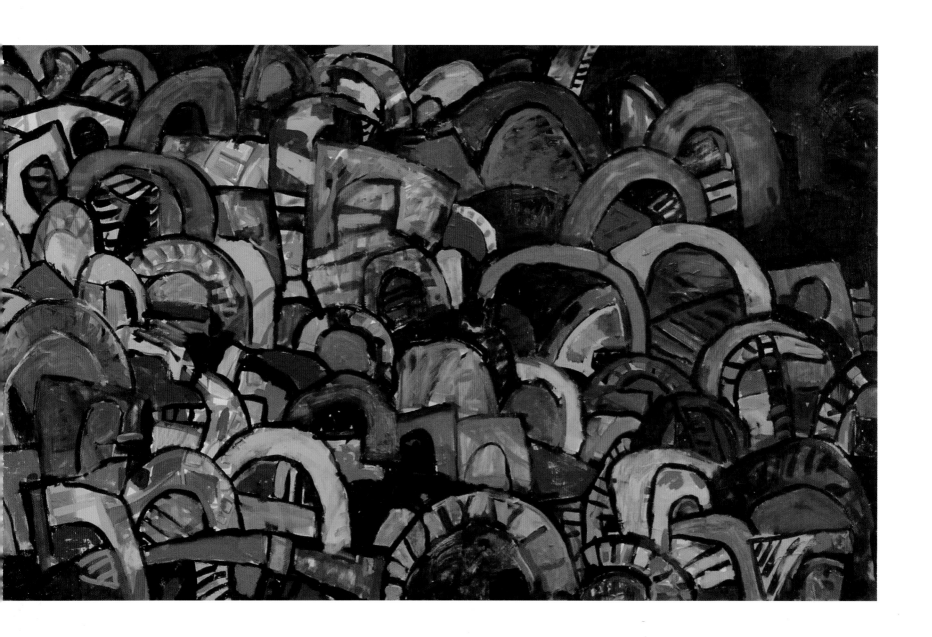

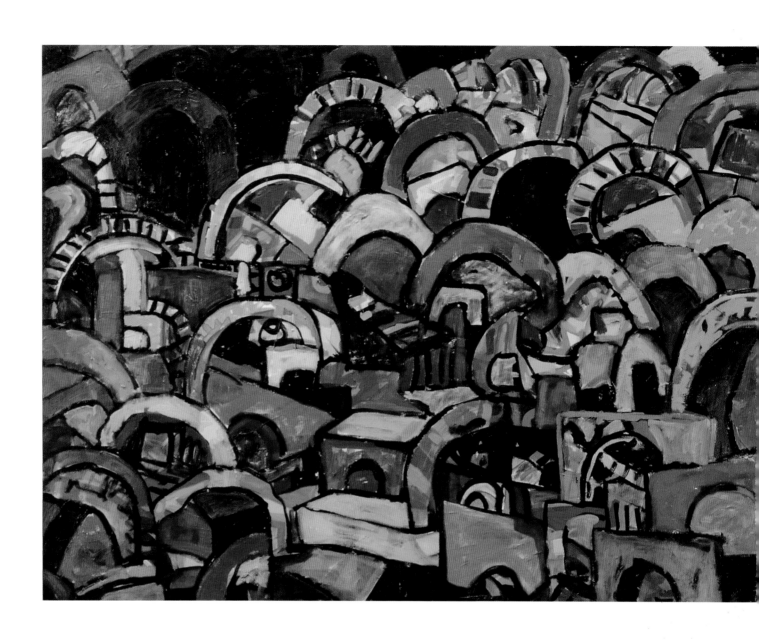

5. *INLAND ROMANCE: PHIL'S BRAKE AND SCRAP*, 2000, ACRYLIC ON CANVAS, 48 x 141 IN.

(far right): 6. *INLAND ROMANCE: BYPASS*, 2003, ACRYLIC ON CANVAS, 38 x 60 IN.

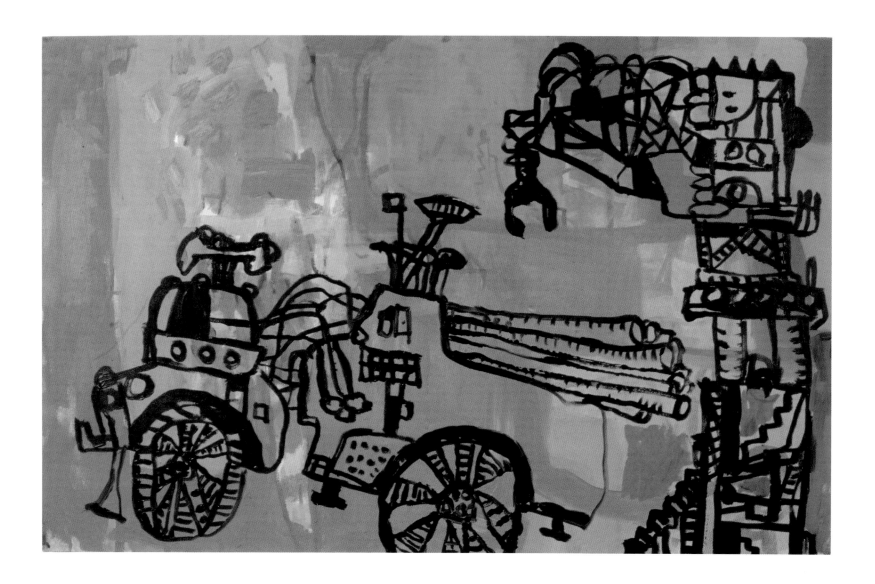

cloissonist design of rounded shapes from which the foregrounded form of a red crane might also be discerned. Similarly, *Phil's Brake and Scrap* (2000, pl. 5), with its mounds of colorful arches, is reminiscent equally of Guston and of children's building blocks in its evocation of a salvage yard. In *Inland Romance: Bypass* (2003, pl. 6), the heavy-duty vehicle begins to emerge as an isolated image against an abstract field of color, evoking the city at work. *Avion* (2004, pl. 9), a truck in full-frame profile, is the first true harbinger of the art to come.

Near the waning of the *Inland Romance* series, Himmelfarb also began pursuing a more stripped-down approach to mark-making that he refers to as *Icons*. An interest in Asian calligraphy grew from a fascination with gesture as an authentic element of both design and subconscious expression. Noting the work of such mid-twentieth-century precursors as Mark Tobey, Morris Graves, and Ulfert Wilke, Himmelfarb crafted an invented language of gestures and figures whose rhythms danced across the surfaces of paper and canvas (pl. 8). These works metamorphosed into more hieroglyphic pieces, exemplified by *Mobilcaster* (2003, pl. 7), in which pictographic elements seem to construct a story using

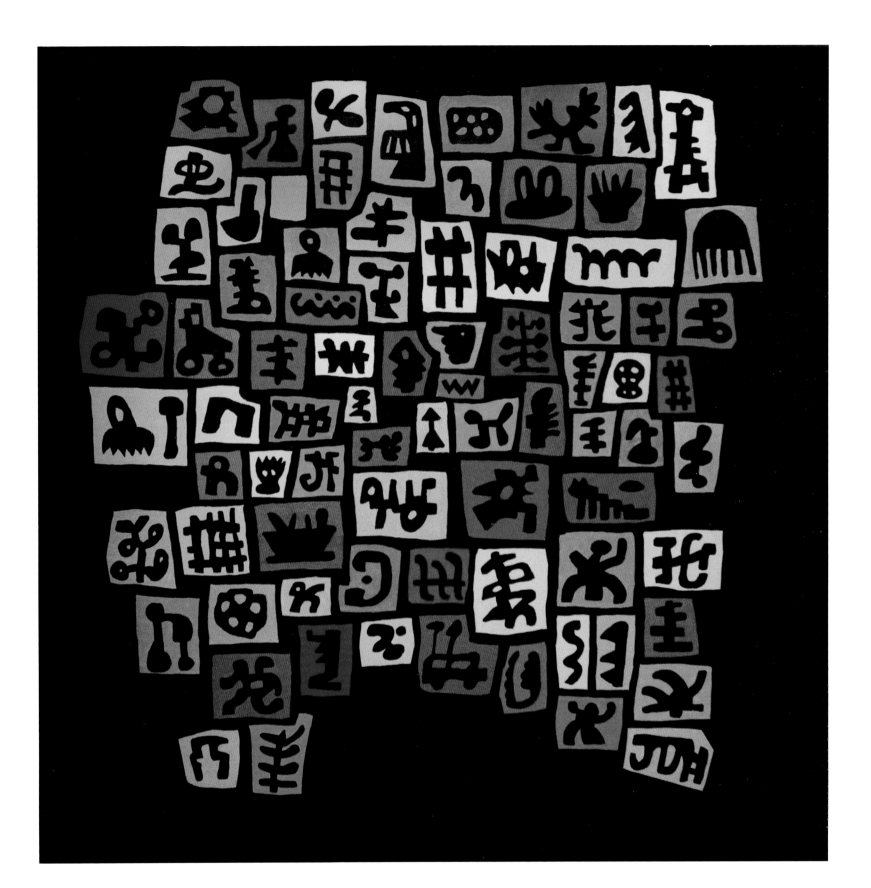

7. *MOBILCASTER*, 2003, ACRYLIC ON CANVAS, 48 x 48 IN.

8. *5/30/79*, 1979, PEN AND INK ON JAPANESE PAPER, 16 x 25 IN.

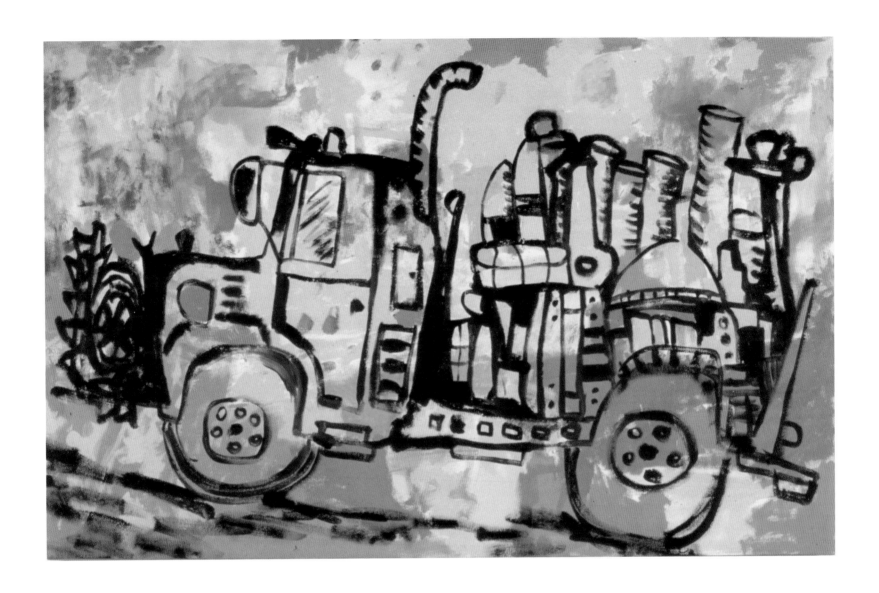

9. *AVION*, 2004, ACRYLIC ON CANVAS, 38 x 60 IN.

emblematic rather than verbal language. Himmelfarb's Rosetta stones depart from his previously busier approach to composition, honing in on his desire to work along the fluid edge between visual information and visual art. Hidden among the various symbols and ciphers of these artworks, images of cars, boats, and trucks can be spotted.

Around 1996, Himmelfarb began utilizing as sketchpads the contents of old library card catalogues long in his possession. Though he seldom deployed the resulting vignettes as preparatory designs for full-scale works, they nonetheless formed a journal of ideas for later reference—itself a kind of tantalizing redeployment of the cards' original functions. At times, the motifs he drew were a play on the title of a book or subject heading typed on the card. Alternatively, Himmelfarb used the cataloguing data to assign a name to the artwork, which otherwise bore no relationship to the composition superimposed upon it. He found their small size was also optimal for recording shorthand a range of complex ideas, many of which expanded motifs born in the *Icons* series. It is in this format that the full image of the truck would be resolved and flourish.

In 2005 and 2006, the truck moved to the forefront of Himmelfarb's work. Catalogue card drawings showing trucks from the driver's side profile reveal his interest in projecting a range of both character and function. With its big red body and balloon tires, *Kidnapping Fiction* (pl. 10) displays the delightful charm of a child's toy. In *Haulin' Hall* (pl. 11), a truck enters a warehouse carting a bed full of cylindrical and other vertical organic forms as if bearing a notional cargo of Isamu Noguchi sculptures. *Alaska Natural* (pl. 12) and *Her Majesty's Plumbing* (pl. 13) are direct renderings of trucks at work, a logger and a crane truck, respectively.

Where these catalogue-card drawings are legible and descriptive, the paintings, prints, and drawings fed by their spirit are even more broadly playful, and the truck's role becomes clear as a platform for Himmelfarb to compose with a variable array of shapes and designs. Compare, for example, a drawing such as *Like Lauren Bacall* (pl. 14) with its bold, elegant economy of ordered, organic forms, to the bubbly painting *Angel* (pl. 15), which resembles a Sunday cartoon of a Dubuffet cargo riding in a Guston-colored world. This latter scrapper is loaded to the gills with items of precious value to pickers and salvagers, but road hazards and junk to the uninitiated.

The personalities of Himmelfarb's trucks also develop in these years. To him, they embody common values, emotions, or experiences. Some are emblems of strength and good character: *Dedication* (2006, pl. 16), *Faith* (2006, pl. 18), and *Courage* (2007, pl. 19). A favorite of the artist, *Perseverance* (2006, pl. 17) is a great illustration of just these principles. It began life as a soft, delicate line drawing on a green field that, in the end, did not satisfy Himmelfarb. Almost as quickly, he brought it back to life by adding the energy and weight of a heavy black outline of a loaded big rig against a busy red ground. The result is a work that seems to be a reinterpretation of Jackson Pollock's transition from Orozco-influenced dark symbolism to the pure non-representation of abstract expressionism. As suggested by its title, it personifies steadfastness in working until the job is complete, in driving one's creativity.

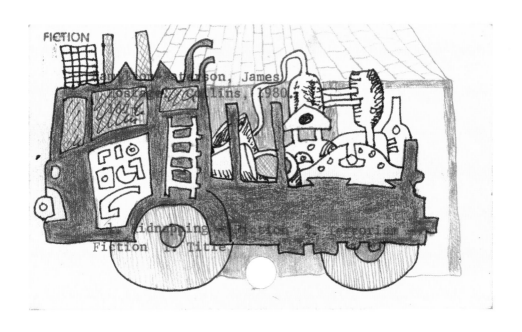

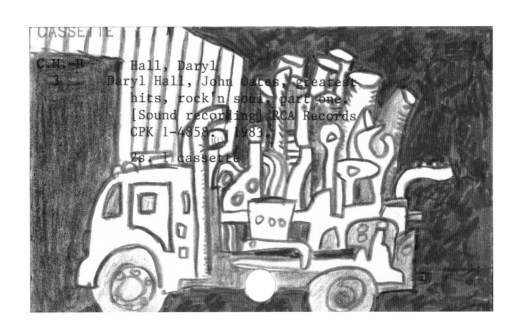

10. *KIDNAPPING FICTION*, 2005, COLORED PENCIL ON LIBRARY CATALOGUE CARD, 3 x 5 IN.

11 *HAULIN' HALL*, 2005, WATERCOLOR ON LIBRARY CATALOGUE CARD, 3 x 5 IN.

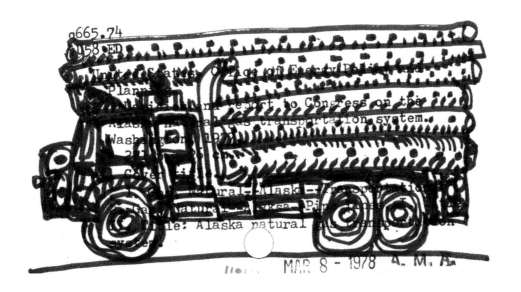

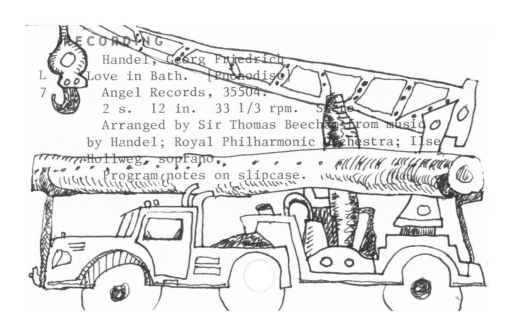

12. *ALASKA NATURAL*, 2006, PEN AND INK ON LIBRARY CATALOGUE CARD, 3 x 5 IN.

13. *HER MAJESTY'S PLUMBING*, 2006, PEN AND INK ON LIBRARY CATALOGUE CARD, 3 x 5 IN.

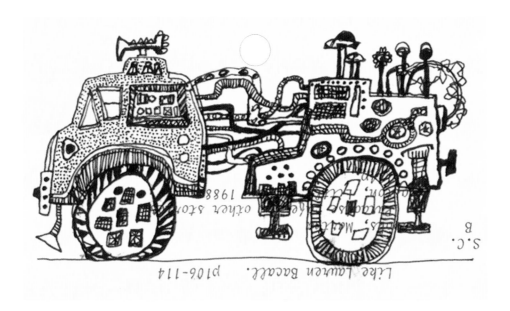

14. *LIKE LAUREN BACALL*, 2003, PEN AND INK ON LIBRARY CATALOGUE CARD, 3 X 5 IN.

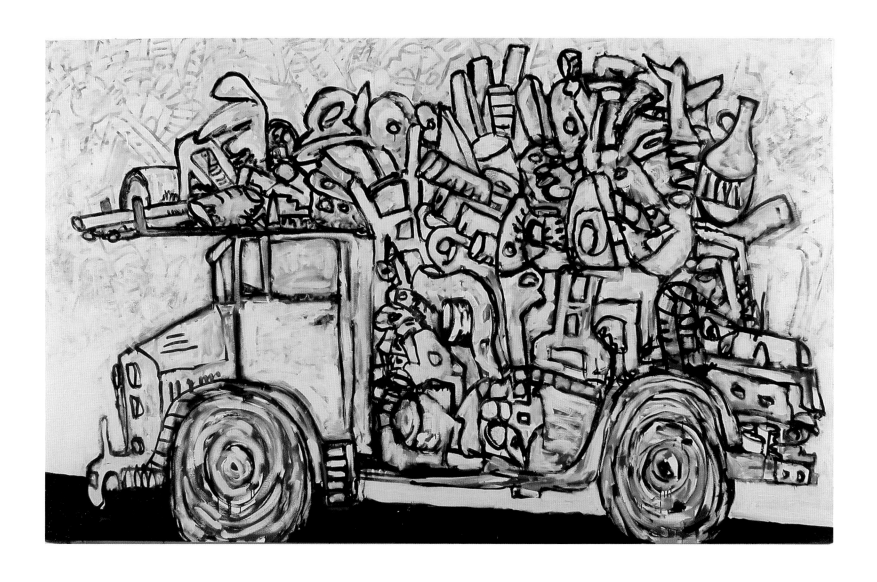

15. *ANGEL*, 2006, ACRYLIC ON CANVAS, 70 x 114¼ IN.

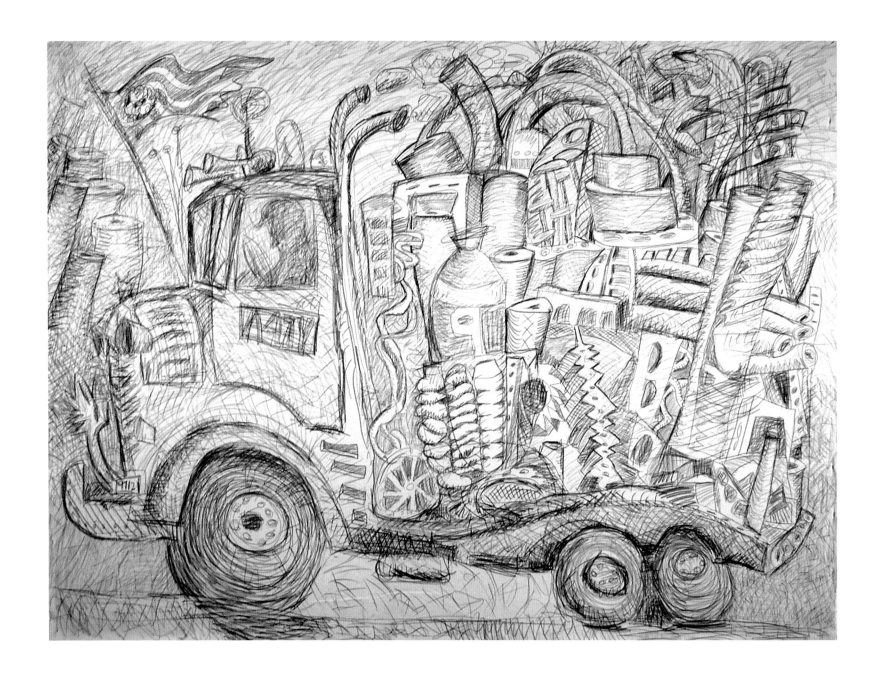

16. *DEDICATION*, 2006, GRAPHITE ON RAW COTTON CANVAS, 71 X 91 IN.

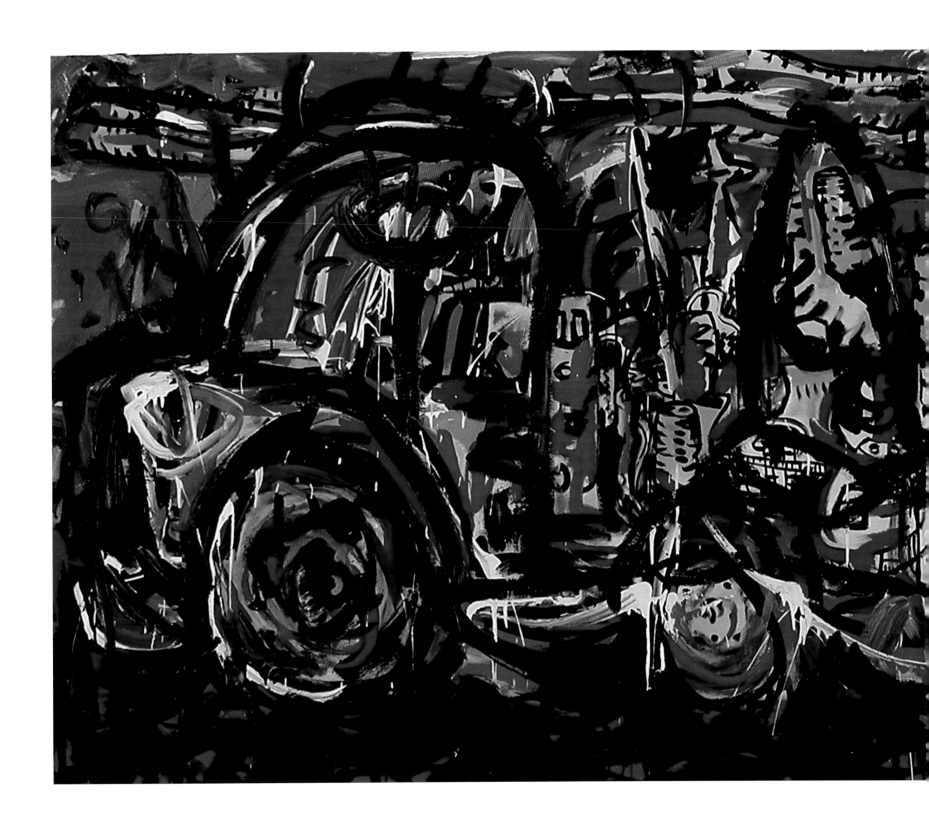

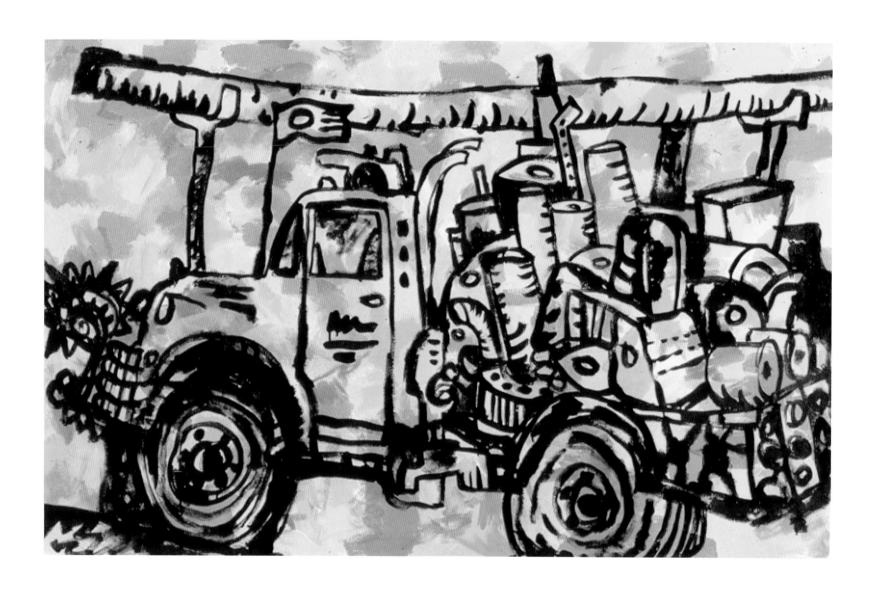

18. *FAITH*, 2006, ACRYLIC ON CANVAS, 38 x 60 IN.

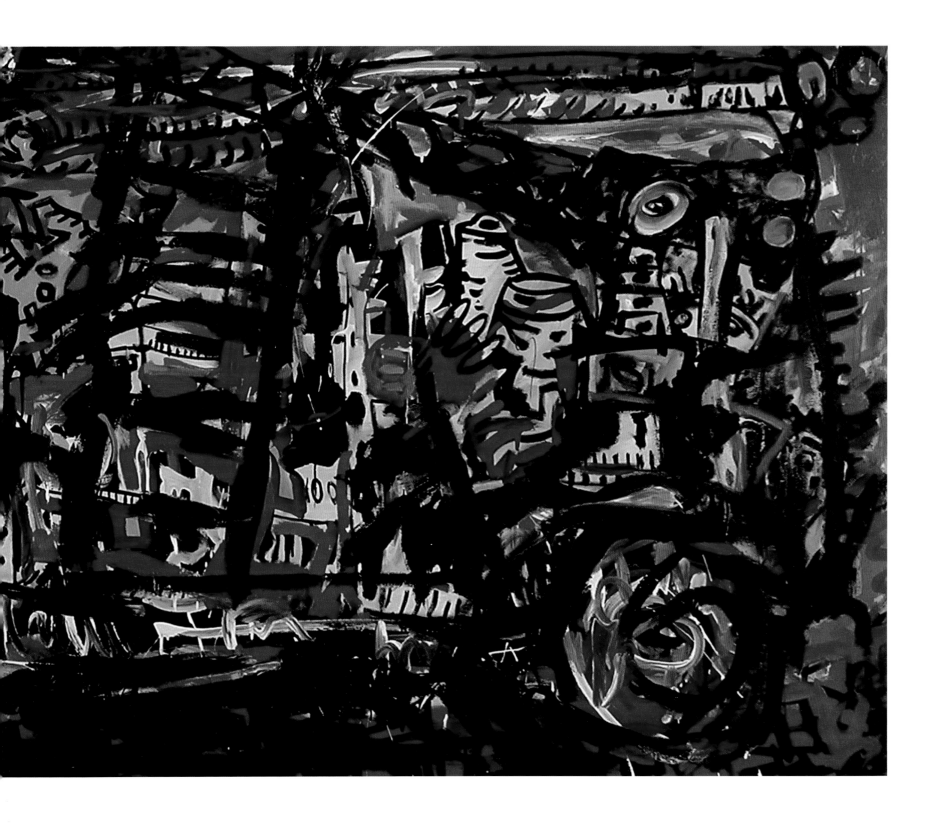

17. *PERSEVERANCE*, 2006, ACRYLIC ON CANVAS, 53½ x 133½ IN.

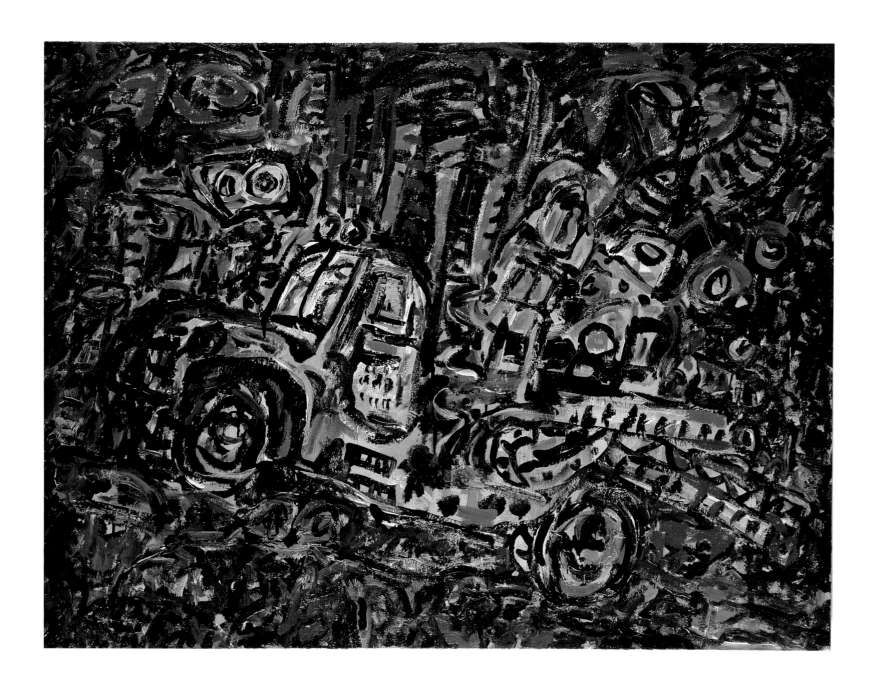

19. *COURAGE*, 2007, ACRYLIC ON CANVAS, 36 x 48 IN.

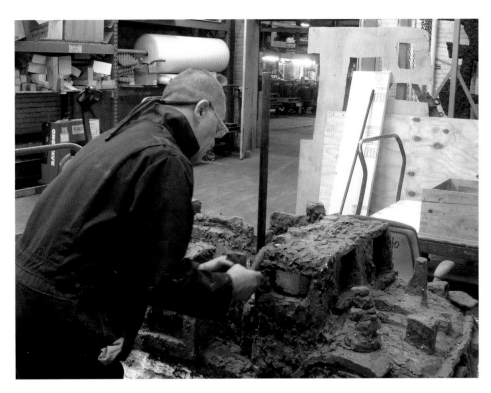

JOHN WORKING ON PLASTICENE FOR *GREEK OPERA* CASTING, KOHLER FOUNDRY, KOHLER, WI, 2007.

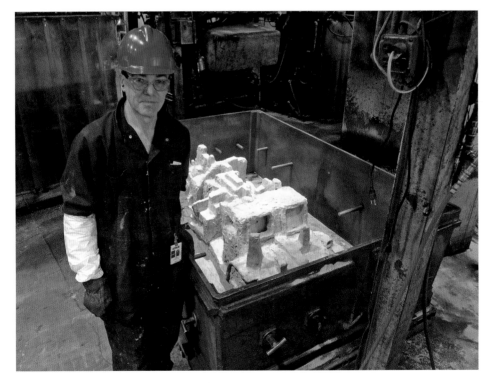

JOHN WITH *GREEK OPERA* PLASTICENE IN FLASK, 2007.

In 2007 another major shift took place in Himmelfarb's approach to his theme. In the winter of that year, the artist began a three-month residency in Wisconsin with the John Michael Kohler Arts Center Arts/Industry program. Begun in 1974, this residency program allows artists unrestricted access to such large-scale industrial processes as brass and iron casting, and to pottery and enamel shops at nearby Kohler Co., internationally regarded designer and manufacturer of kitchen and bath fixtures. Technicians, engineers, and artisans at the plant are available for consultation, but the fabrication process, from start to finish, is purely the artist's own. The result for Himmelfarb was his first serious, sustained move to working in three dimensions.

Left to his own devices, Himmelfarb set about making a series of wax and plasticene truck sculptures from which he formed sand molds and cast them in iron, brass, or bronze. The twenty resulting sculptures ranged in size from ten inches to six feet. Expressions in form rather than color, most were patinated in verdigris or rust, reflective of their industrial fabrication (medium) and their commercial purpose (subject). Visually, the best descriptor of Himmelfarb's Kohler haulers is that they are molten and lumpy, not unlike the processes that created them. These hulking vehicles are burdened by and often indistinguishable from their creaky freight or mechanical functions (left).

With their new emphasis on weight and mass, Himmelfarb's truck sculptures meld form and function. The small bronze *Fidelity* (pl. 20) embodies a very specific concept of a working vehicle with lifting and plowing capabilities, its hard edges rounded off and shorthanded. *Mesa* (pl. 21), however, changes its attitude from side to side. Seen from the front, the cab is cartoonish, its windows like sunken eyes and the grill a big smile. The driver's side presents a mountainous old livestock hauler with its rickety wood slats lumbering down the road with its cargo and incumbent "animal emissions." The rear is less descriptive, with folded shapes cascading off the back like a waterfall. Finally, the passenger side is wide, flat, and relatively unarticulated, like the butte after which he named the work.

Himmelfarb also pushed some sculptures toward full abstraction. In *Bird in Hand* and *Patience* (pls. 22 and 23), most distinguishing features are obliterated and the subject is recognizable mainly by wheels and distinctive cab grills. It is almost as if he took the twisted metal of Chamberlain's steel sculptures and combined it with the freely expressive, process-evident sculpture of de Kooning and the lumpy figural groupings of Reuben Nakian. Moreover, Himmelfarb had truly found a way to fuse the expansive energy of his drawings into three dimensions.

From this time, the image of the truck was essentially inseparable from any other art making Himmelfarb pursued. He continued to model truck sculptures in 2008 and 2009, mainly in clay, which allowed him to unlock the mass of the cast sculptures into constructed forms that more closely approximated his ongoing work in two dimensions. The

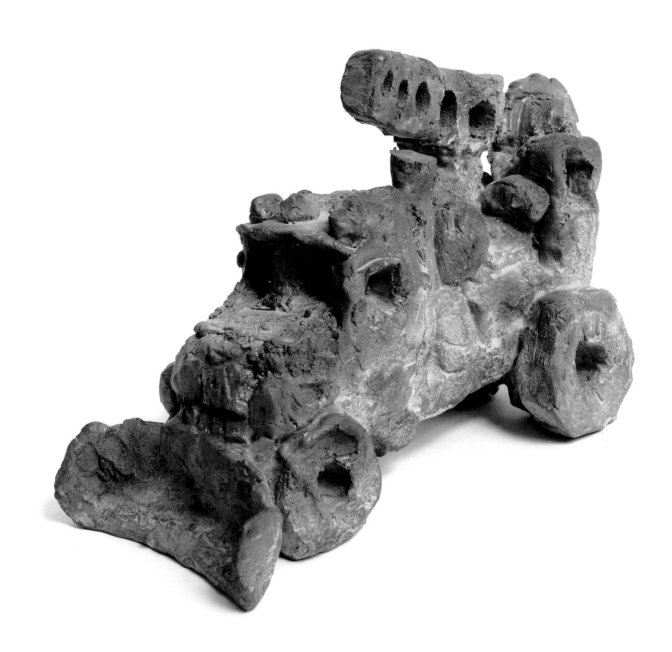

20. *FIDELITY*, 2007, BRONZE, EDITION 4, 7 x 10 x 3 IN.

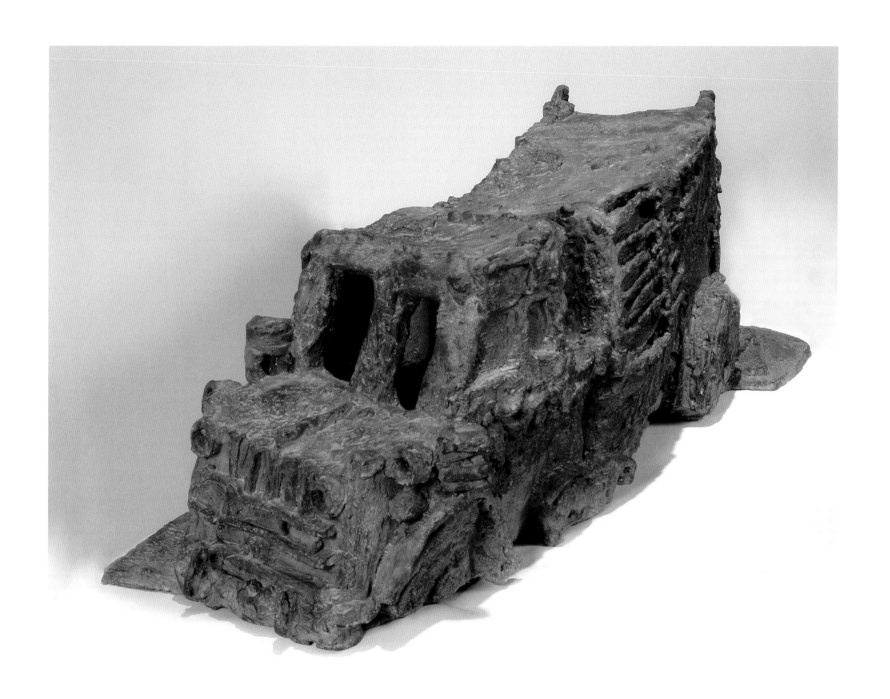

21. *MESA*, 2007-09, BRONZE, 15½ x 41 x 19 IN.

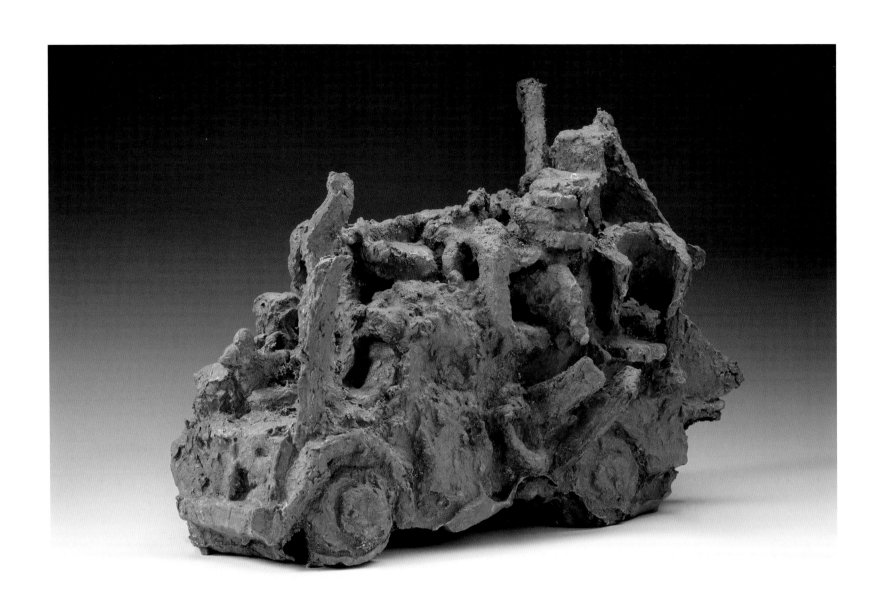

22. *BIRD IN HAND*, 2007, CAST IRON, 16¼ x 27 x 13 ¾ IN.

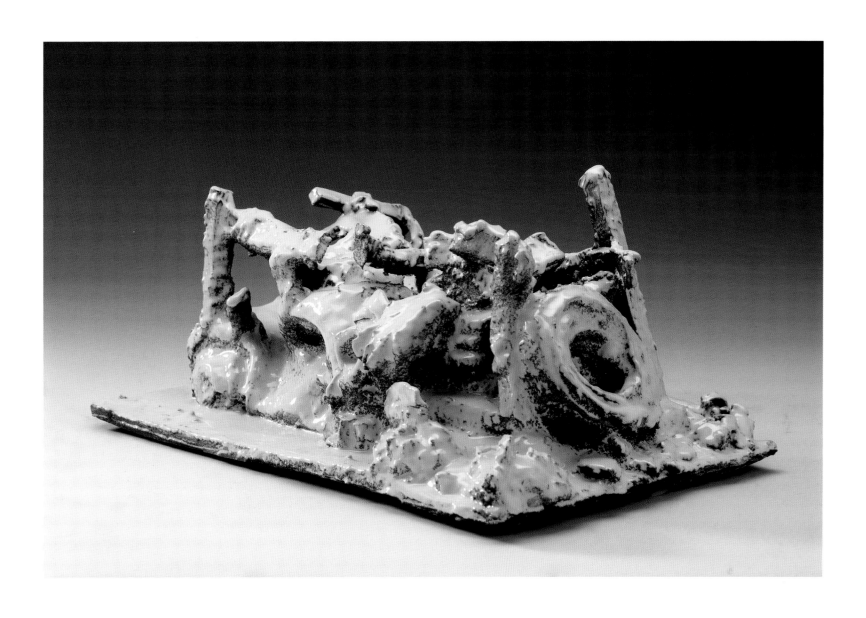

23. *PATIENCE*, 2007, ENAMELED CAST IRON, 11¼ x 23¾ x 15¾ IN.

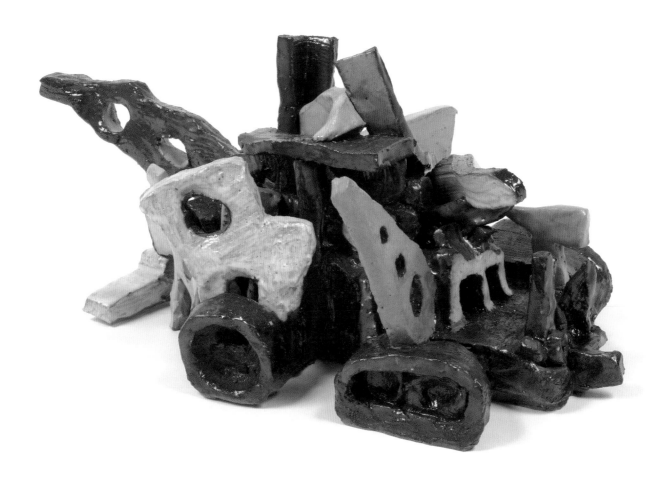

24. *LANDER*, 2008, CERAMIC WITH MULTICOLORED GLAZE, 6½ x 15 x 9 IN.

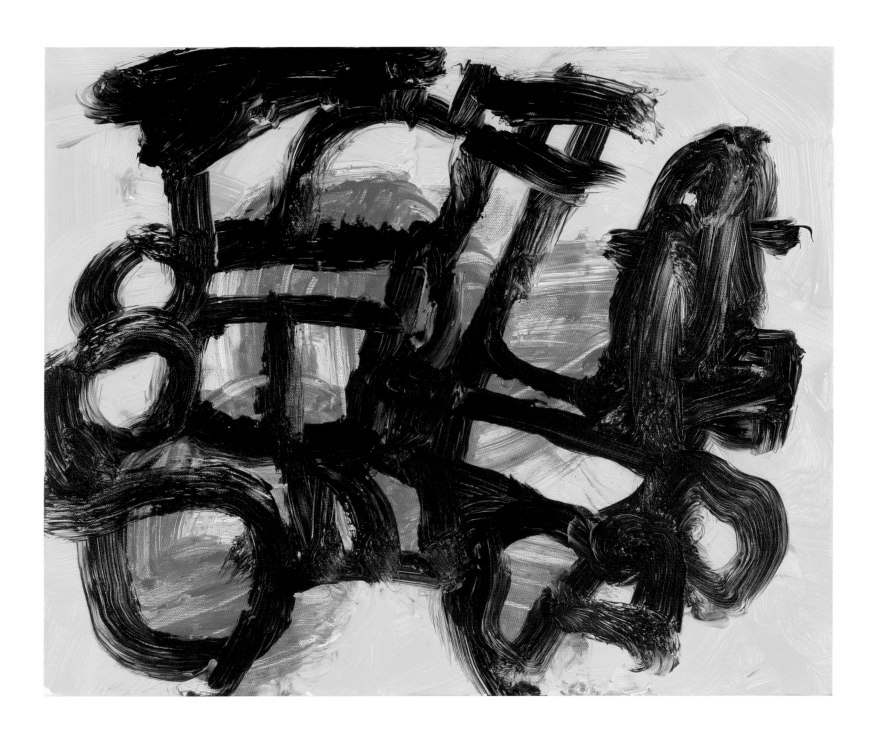

25. *FRONTLINE*, 2008, ACRYLIC ON CANVAS, 16 x 20 IN.

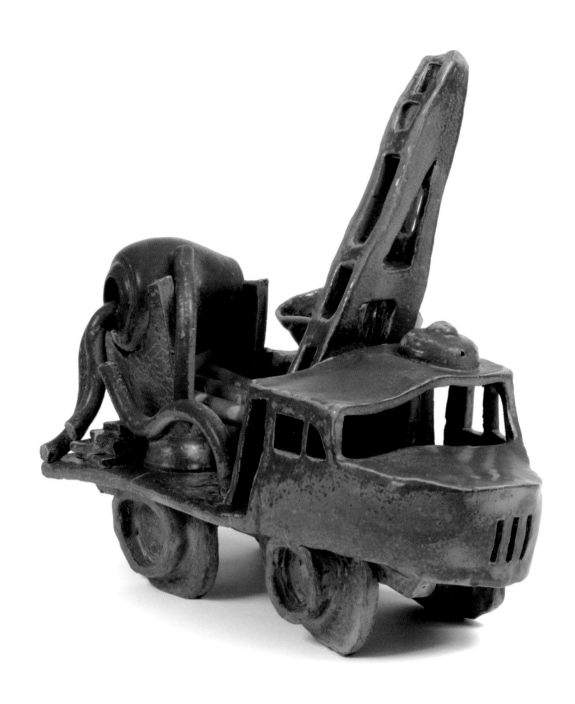

26. *CALVERTINA*, 2009, CERAMIC, 16 x 10½ x 17 IN. IN COLLABORATION WITH AARON CALVERT.

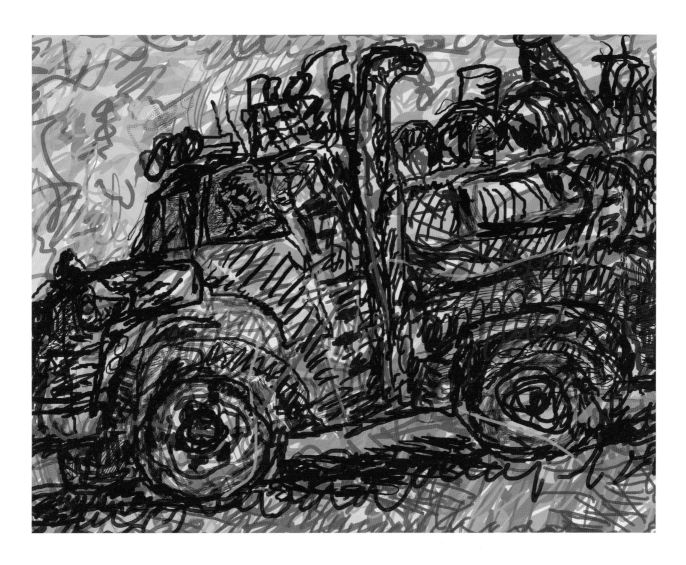

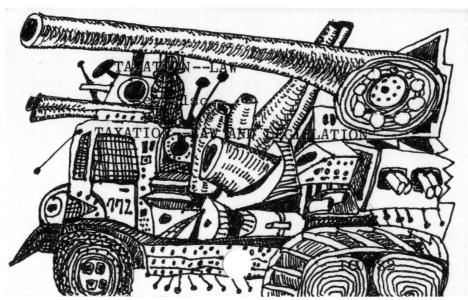

27. *OUTWARD*, 2008, CREATED IN PHOTOSHOP, ARCHIVAL INKJET PRINT, 16½ x 21½ IN.

28. *TAXATION LAW*, 2008, PEN AND INK ON LIBRARY CATALOGUE CARD, 3 x 5 IN.

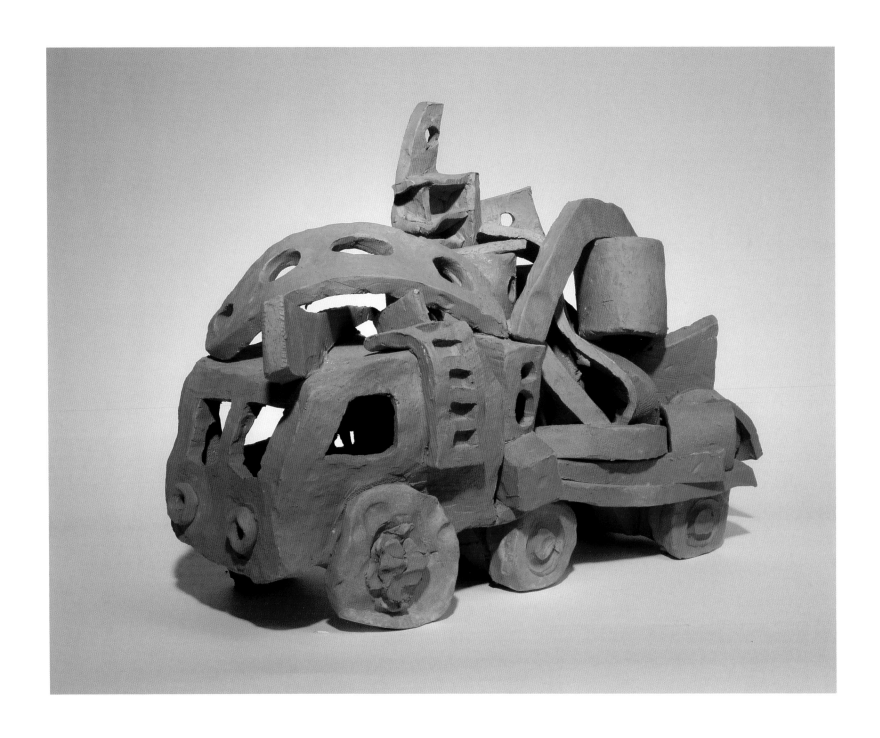

29. *MODERN BURDEN*, 2009, UNGLAZED TERRA COTTA, 13½ X 19 X 8 IN.

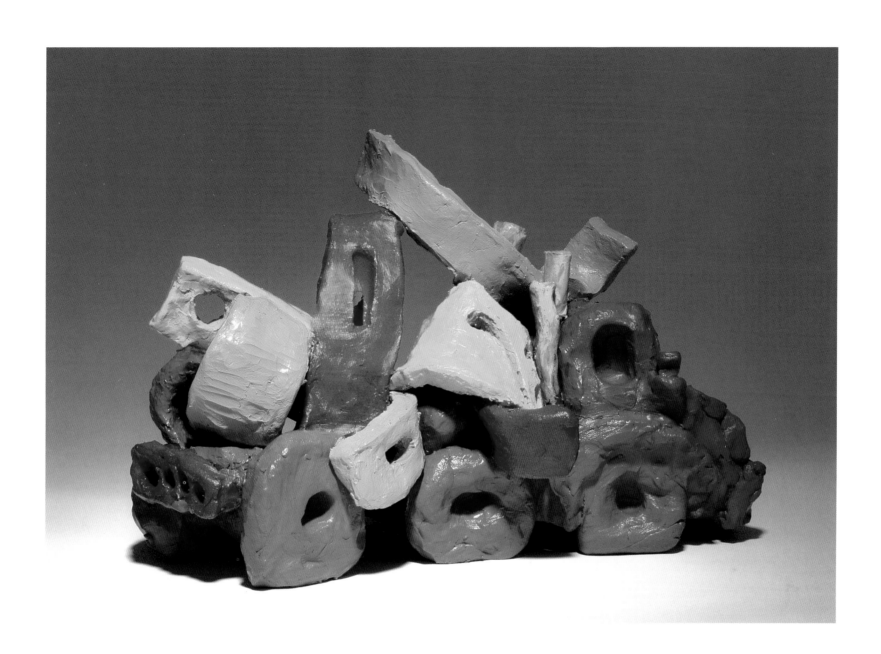

30. *TRUCK TO MARKET*, 2009, PAINTED CERAMIC, 8 x 12 x 6½ IN.

multicolor glazed ceramic *Lander* (pl. 24), with its elliptical tires and wild array of thin vertical and arced slabs in the truck's bed, relates to the playful finger-painting quality of *Frontline* (pl. 25). *Calvertina* (pl. 26), a polychrome ceramic, is more literal in its rendering of a truck outfitted with cement mixer and lifting arm and recalls Himmelfarb's sketchlike print *Outward* (pl. 27), as well as his reengagement with the more detailed notational work of catalogue cards such as *Taxation Law* (pl. 28). With their more stylized and layered components of vehicle and cargo, *Modern Burden* (pl. 29), an unglazed terracotta, and *Truck to Market* (pl. 30), a painted ceramic, call to mind model toys and pave the way for later planar constructions.

In 2009 Himmelfarb turned to paintings and sculptures more within the confines of monochromy, typically a feature of his prints and drawings. *Forebearance* (pl. 31) and *Revelation* (pl. 32) are large acrylics in black and white, rendered in a Gustonesque style reminiscent of cartoons and early animation. *Revelation,* in particular, springs from Himmelfarb's *Inland Romance* accumulations of repeated forms, and *Double Negative* (pl. 33) looks like a Jean Tinguely sculpture fell into the bed of a Terry Gilliam truck, betraying a lightness of mood and hand beginning to re-form in the two-dimensional work.

Lingering inside Himmelfarb, however, was the notion that emerged back at Kohler to take his art into the realm of assemblage by using a real truck as an armature for sculpture. In 2008 he found an old International KB-1 pickup onto which he welded a seemingly random, but carefully composed, assortment of implements and mechanisms, including rusty pipes, drums, shovels, and funnels. He then painted the whole thing stop-sign red and aptly named it *Conversion* (pls. 34 and 35). It is not clear if the freight is of use or junk, if the truck is going to work or the salvage yard. Himmelfarb was reminded of the scrappers he saw on the streets of Chicago, whose loads were piled high with a precarious artfulness, as well as pictures he'd seen of Pakistani and Indian rococo-painted cargo trucks. The result is a work that lies somewhere on a line through the Joads to the Beverly Hillbillies to Mad Max. To the bright and jaunty *Conversion*, Himmelfarb added a few surprises in the truck's interior: this old-school vehicle does not have GPS or a DVD player but is outfitted instead in analog with an Underwood manual typewriter and an 8mm film projector loaded with Mack Sennett slapstick comedies.

This same warmth is even more expansive in Himmelfarb's few paintings from this period. In the large-scale acrylics *Hero* (pl. 36) and *Setting Forth* (pl. 37), each from 2010, the mood is felicitous, as trucks chug across fauve-colored landscapes, with coiled masses of stuff springing out of their beds in every direction like a bad hair day. Himmelfarb's animated drawing style and brushwork accentuate their bumpy journey. It's as if the artist piled the contents of *Inland Romance* paintings onto the vehicles and sent them packing.

Himmelfarb followed up his adventures with *Conversion* by creating a more formal, fully operational work, *Galatea* (2010, pls. 38 and 39). Here, a classic REO Speedwagon similarly labors under the weight of its odd cache of treasures. A tighter composition than *Conversion*, the elements making up *Galatea* are less idiosyncratic and more essential in form (cylinders and cubes), Himmelfarb's nod to constructivism and to the artisanally sculptural qualities of the vintage REO. The title is a tribute to the myth of the sculptor, who aims to turn a beautiful but inanimate creation onto a living thing. Clearly, Himmelfarb's concept of perfection is not classically ideal, but well-aged and comfy.

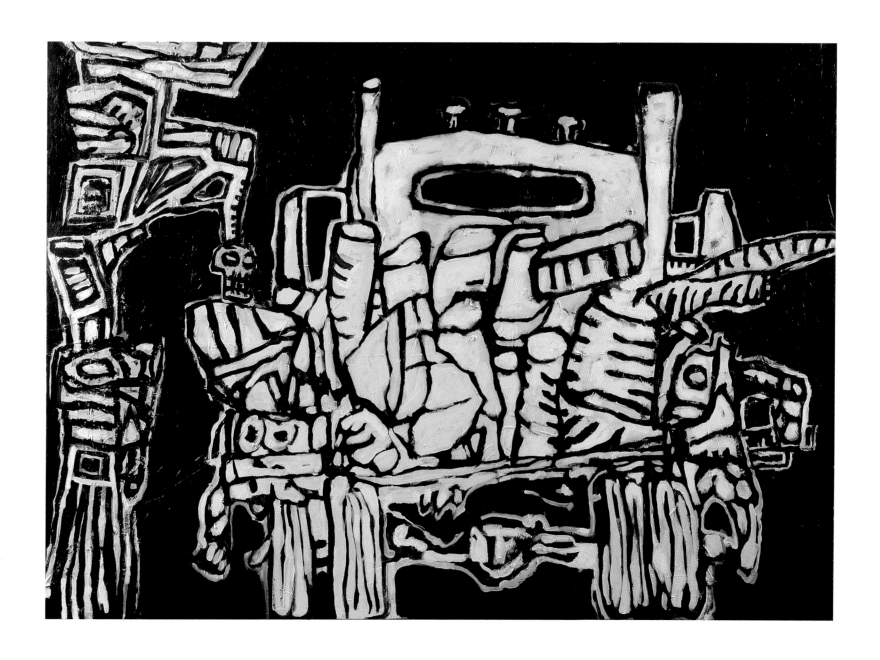

31. *FORBEARANCE*, 2009, ACRYLIC ON CANVAS, 54 x 76 IN.

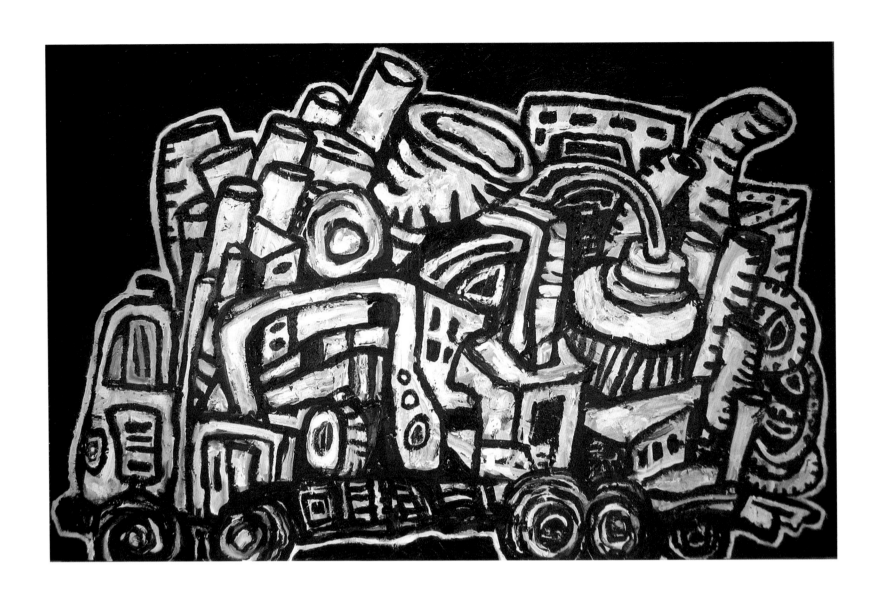

32. *REVELATION*, 2009, ACRYLIC ON CANVAS, 38 X 60 IN.

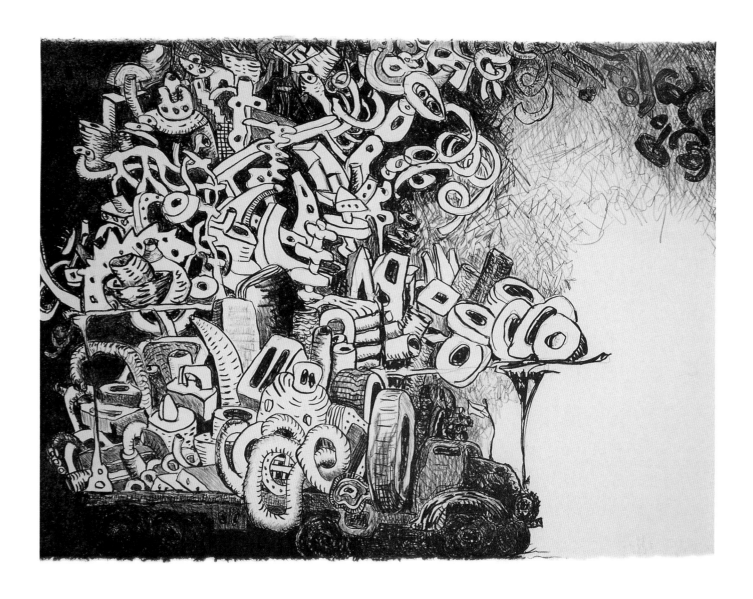

33. *DOUBLE NEGATIVE*, 2009, LITHOGRAPH, 22 x 30 in.

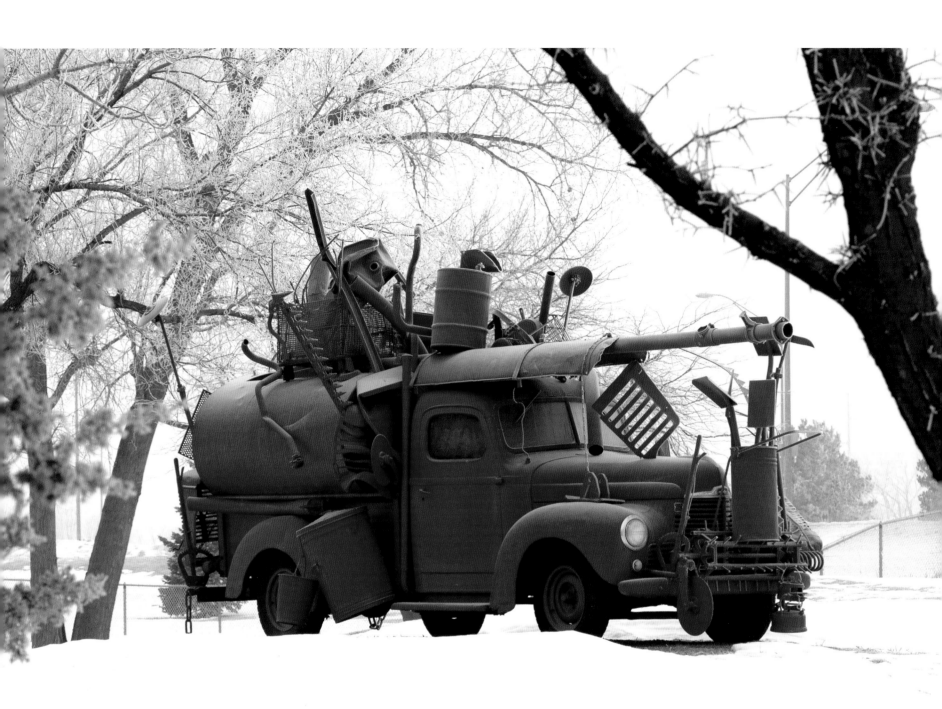

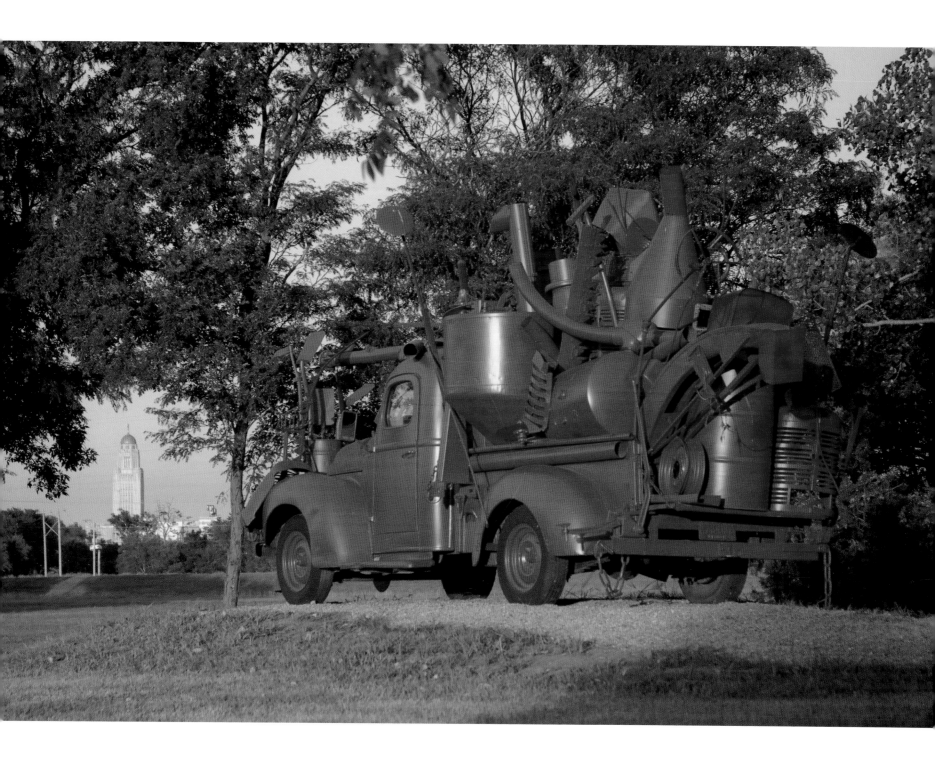

34 AND 35. *CONVERSION*, 2009, 1949 INTERNATIONAL HARVESTER KB-1 TRUCK AND FOUND OBJECTS,
11 X 25½ X 10 FT.

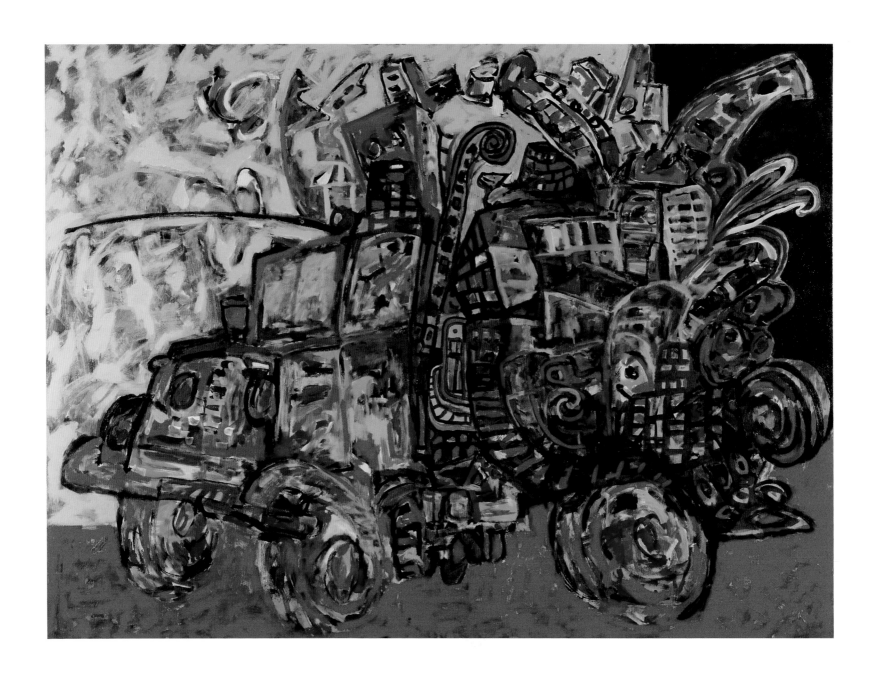

36. *HERO*, 2010, ACRYLIC ON CANVAS, 66 X 90 IN.

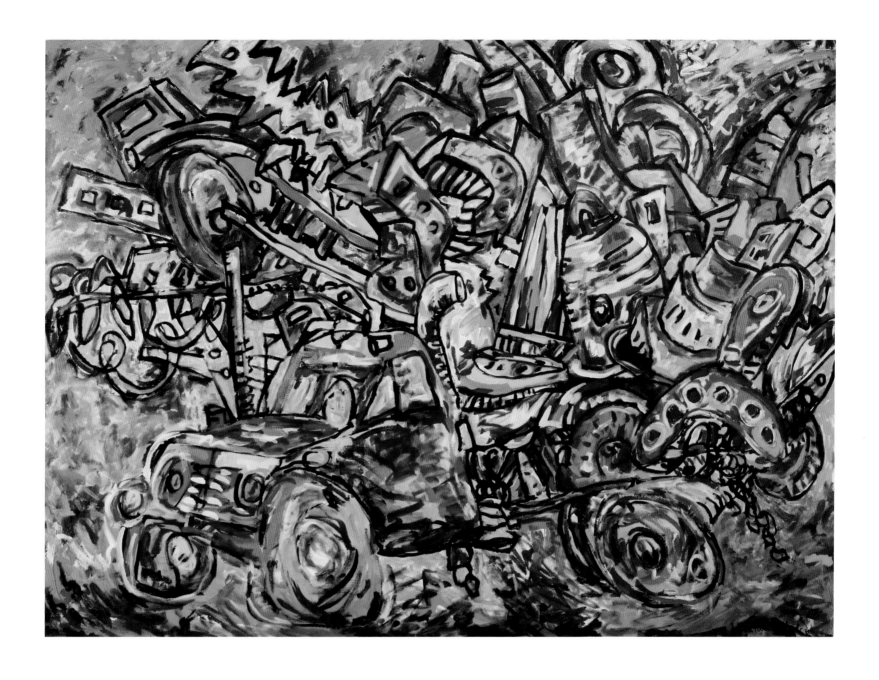

37. *SETTING FORTH*, 2010, ACRYLIC ON CANVAS, 66 x 90 IN.

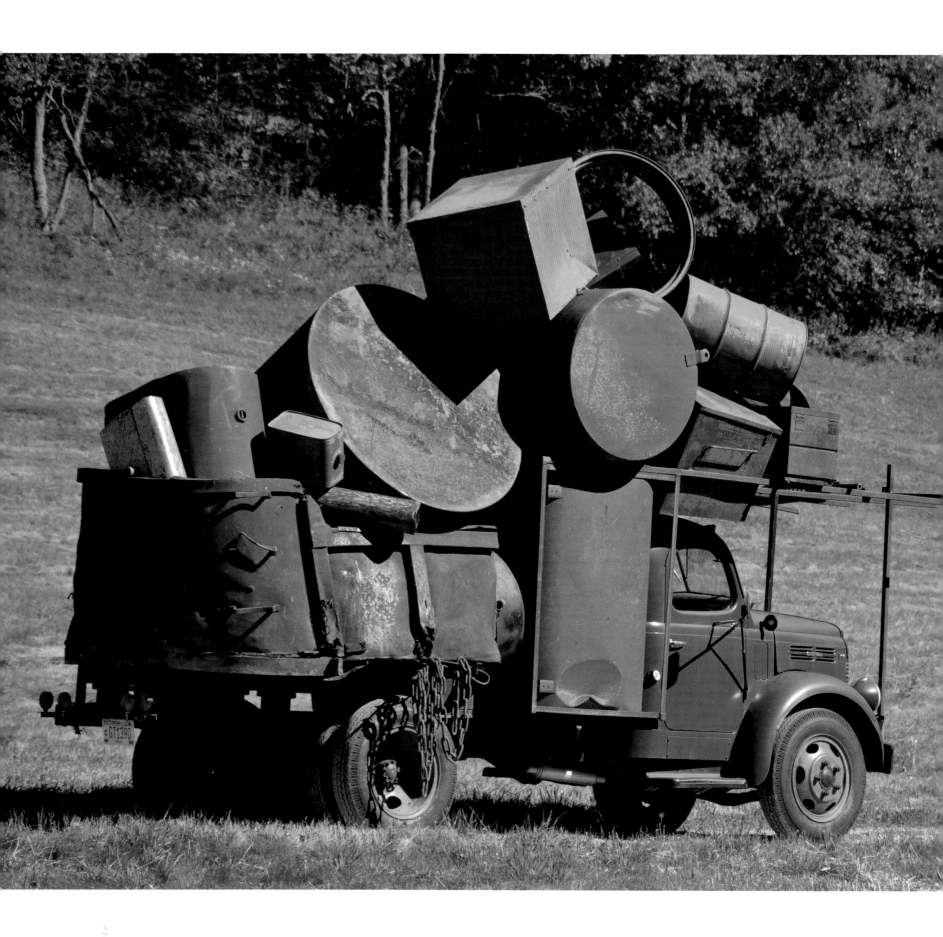

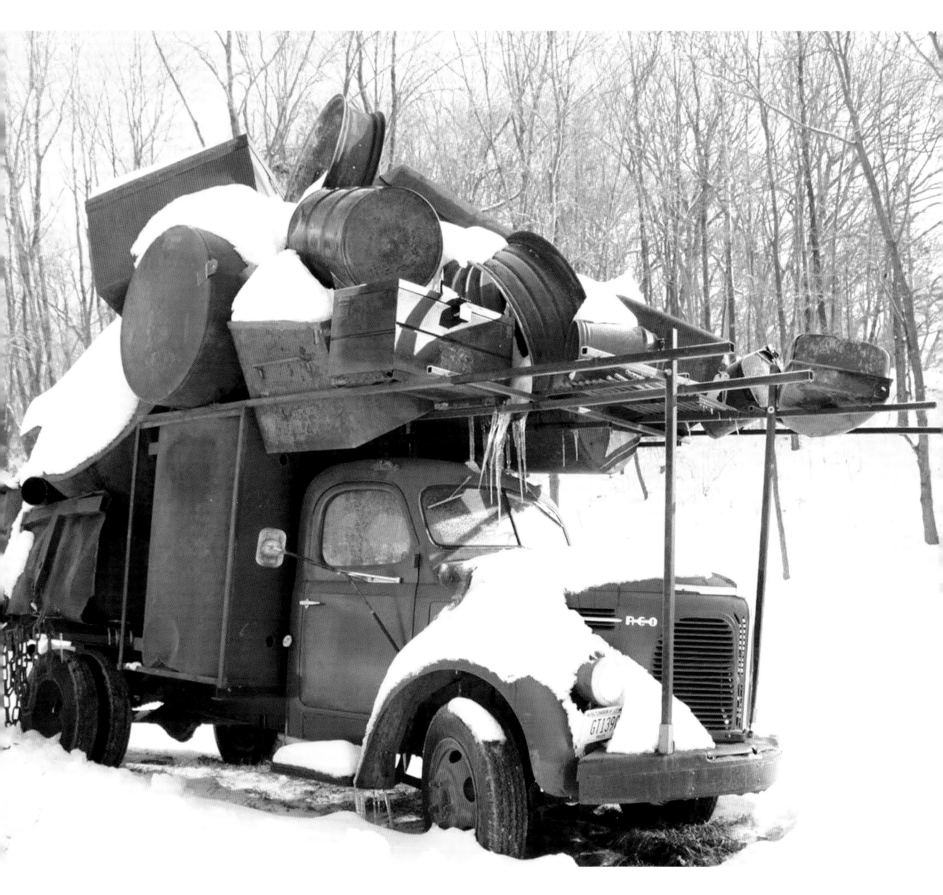

38 AND 39. *GALATEA*, 2010, 1948 REO SPEEDWAGON TRUCK WITH WELDED FOUND OBJECTS,
14½ X 25 X 8½ FT.

Turning back from the street to the studio, Himmelfarb has continued making pedestal-sized sculptures. Several recent works have been constructed of interpenetrating planes of steel or wood that are then assembled into truck forms, as if translating into three dimensions the artist's recurring predilection for contours and silhouettes. Aiming at greater simplicity, the wildly varying shapes of cargo are replaced by an emphasis on the general configurations of a working vehicle. The rugged fabrication and exaggerated profile of *A Bend in the Road* (pl. 40) enhance its reading as a construction crane, as does its rendering in Caterpillar yellow. *Blue Motive* (pls. 41 and 42) and *The Road to Herron* (pl. 43), made up of jigsawed plywood pieces to which colorful prints have been adhered, have the youthful exuberance of wooden toys. Himmelfarb then scaled up the method and feeling of such sculptures into the safety-orange steel *The Road Ahead Leaves a Trail Behind* (pl. 44), an evocation of tractors, tanks, and other heavy duty moving machines outfitted with track systems. In 2012, he redeployed this work in an installation that, when combined with discarded fuel tanks and oil drums, yielded the artist's most direct social commentary to date regarding consumerism and the energy economy.

In Himmelfarb's latest paintings and prints, this same reductive, stylized manner has also taken hold. The trucks are not lost in a beautiful sea of expressionistic brushwork but are silhouetted firmly against simple planes. The screenprint *Pipe Down* (pl. 46) features a pipe hauler stacked to capacity, rendered in black and white against a stark red background. In its companion piece, *Pipe Up* (pl. 45), standing tubes constitute the single load. Finally, in *A Moment of Silence* (pl. 47), Himmelfarb's army-green truck recalls his earlier *Icons,* as the image is pared down to the frame-filling profile of a vehicle bearing few but essential components. After his sculptural forays with realism, this seems a natural transition.

A decade in, it's easy to see the expressionistic power and metaphorical range the truck holds for Himmelfarb. And as a viewer, it's equally hard not to engage with these works. They contain imagery that is so familiar and speaks volumes about the ways life works, addressing the materials society uses (and discards), and our toted baggage that's both physical and psychological. They look forward, while dragging bits of the past with them, as people are (and art is) wont to do. This is the journey Himmelfarb is making, and since he always leaves room in the cab, the viewer is welcome to hitch a ride.

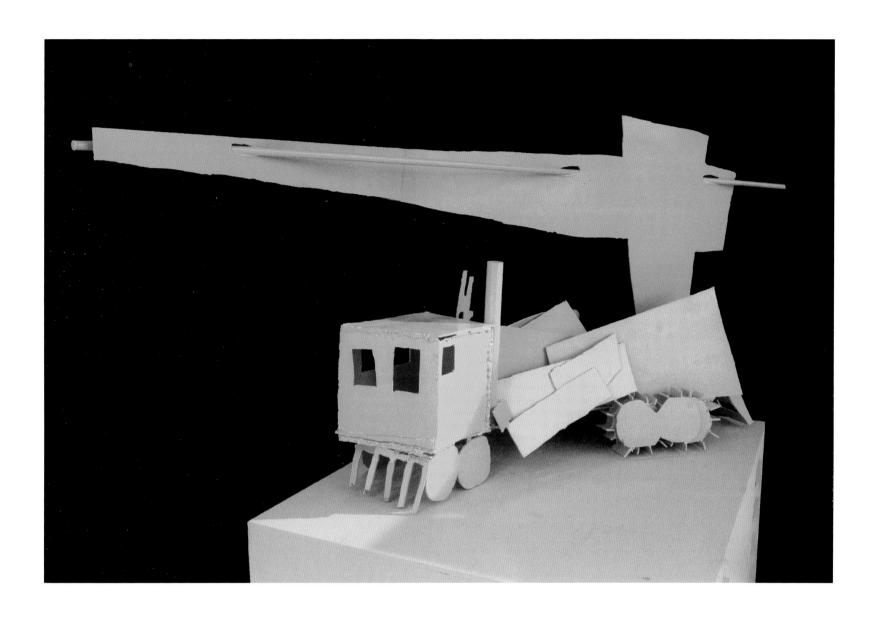

40. *A BEND IN THE ROAD*, 2011, POWDER-COATED STEEL PLATE, 43 x 25 x 75 IN.

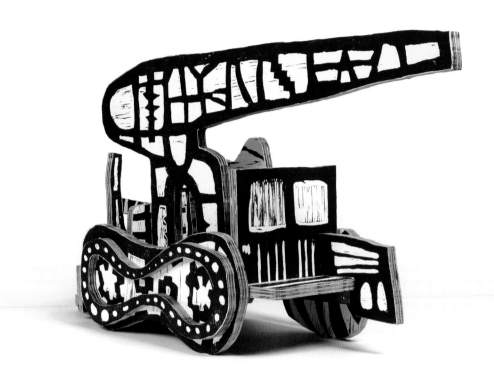

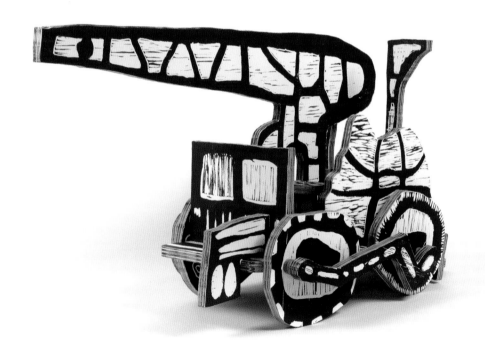

41 AND 42. *BLUE MOTIVE*, 2011, WOODBLOCK PRINT ON BLOCKS OF WOOD, EDITION 9, 21½ X 44 X 15 IN.

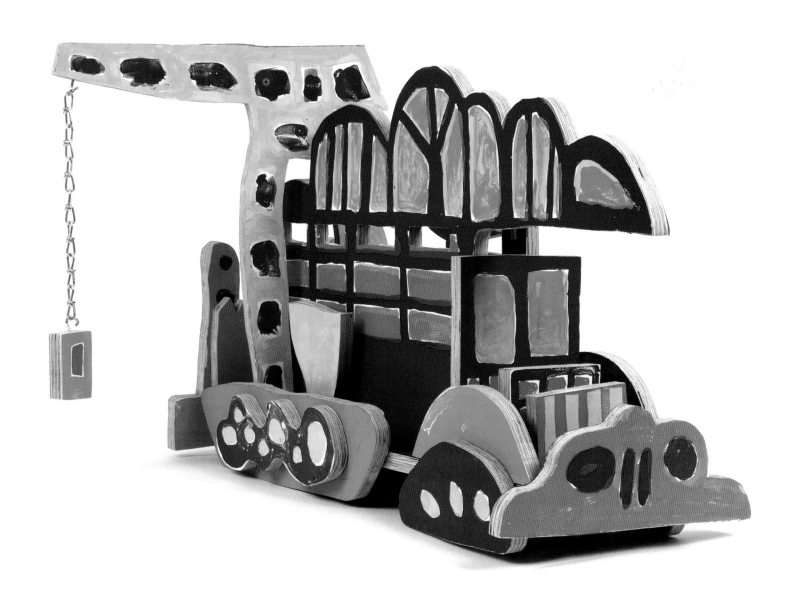

43. *THE ROAD TO HERRON*, 2012, SILKSCREEN ON PAPER MOUNTED ON BLOCKS OF WOOD, EDITION 15,
22½ x 30½ x 21 IN.

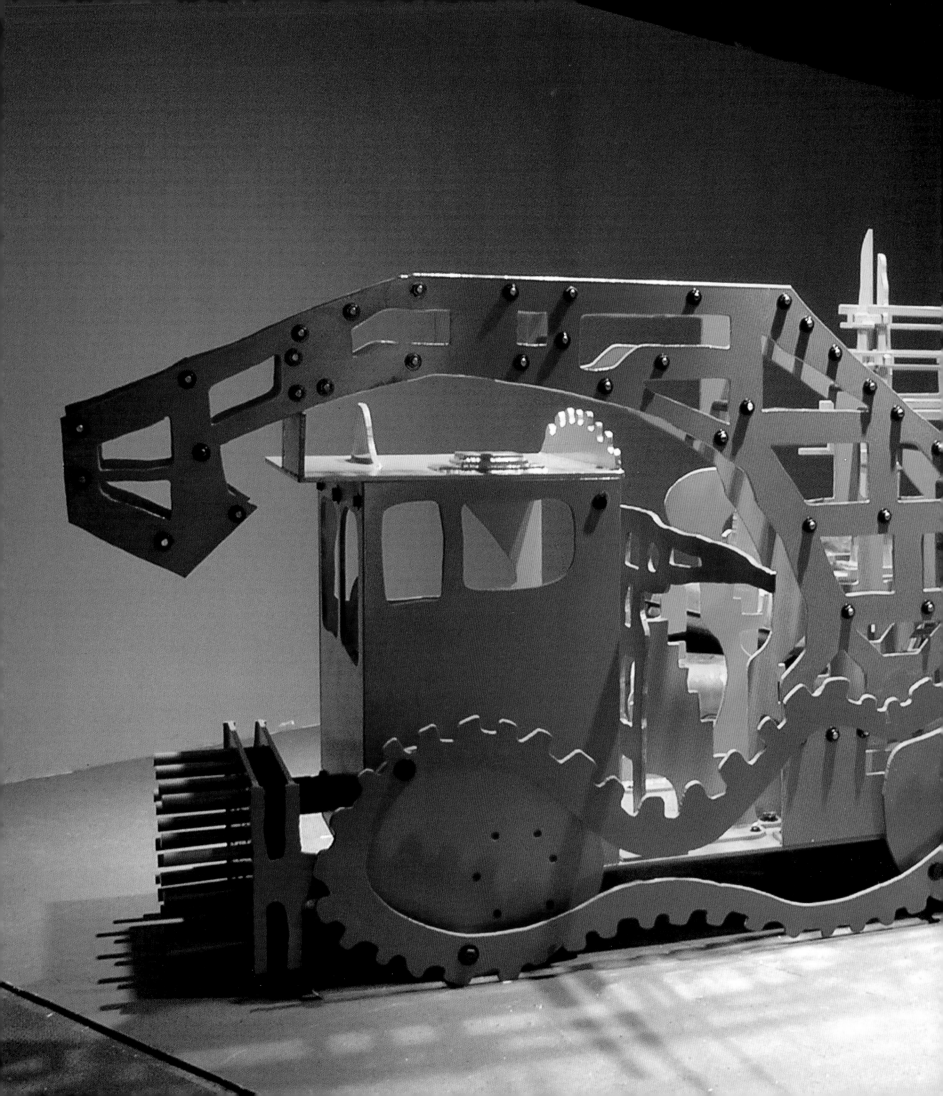

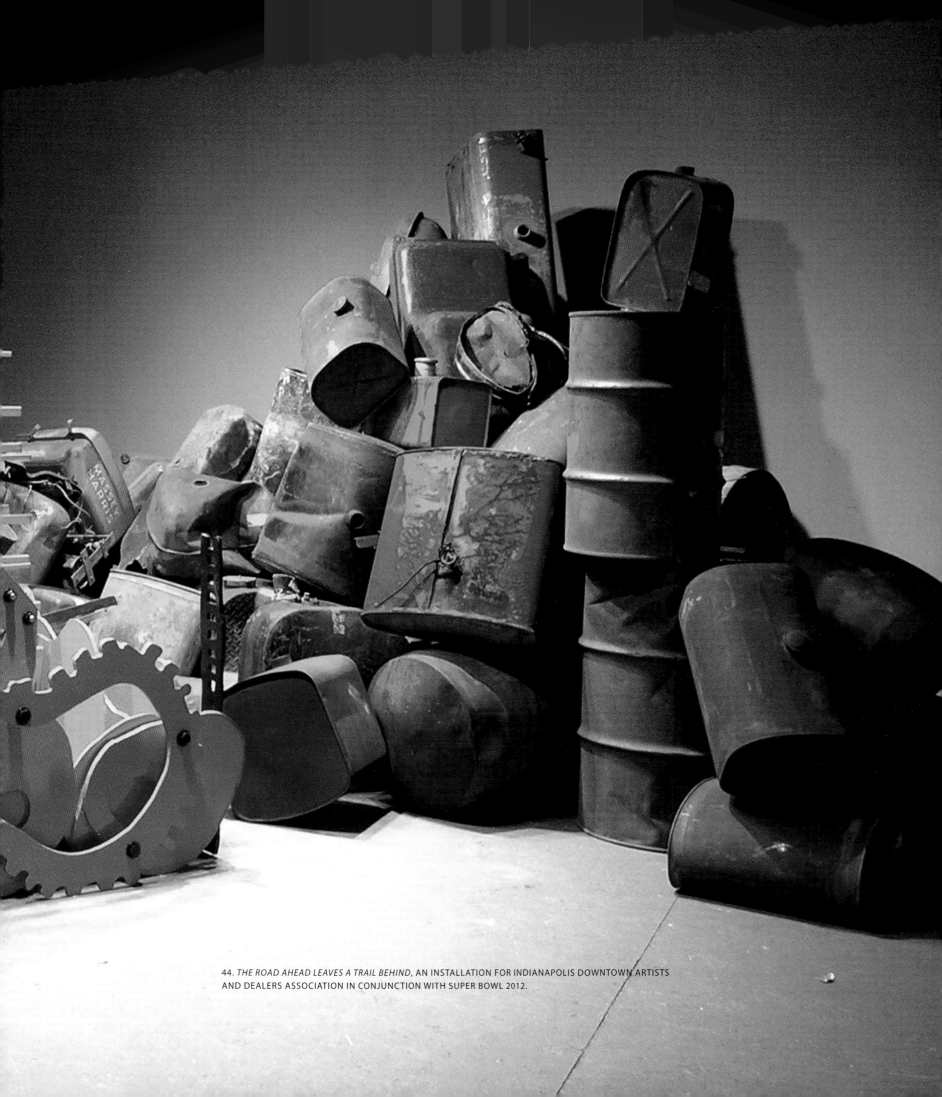

44. *THE ROAD AHEAD LEAVES A TRAIL BEHIND*, AN INSTALLATION FOR INDIANAPOLIS DOWNTOWN ARTISTS AND DEALERS ASSOCIATION IN CONJUNCTION WITH SUPER BOWL 2012.

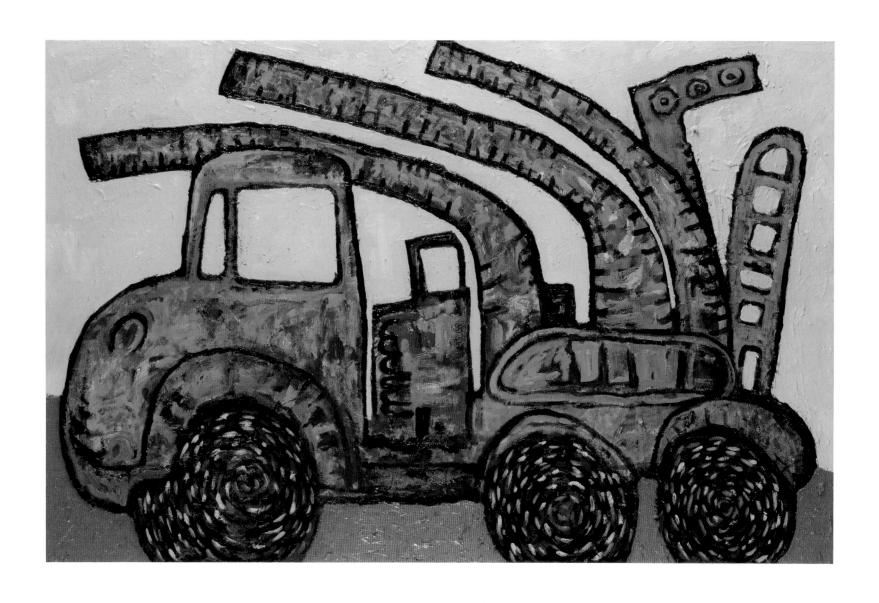

(opposite, top): 45. *PIPE UP*, 2011, SCREEN PRINT, 21¾ x 29¾ IN.

(opposite, bottom): 46. *PIPE DOWN*, 2011, SCREEN PRINT, 21¾ x 29¾ IN.

(above): 47. *A MOMENT OF SILENCE*, 2012, ACRYLIC ON CANVAS, 38 x 60 IN.

TRUCKS

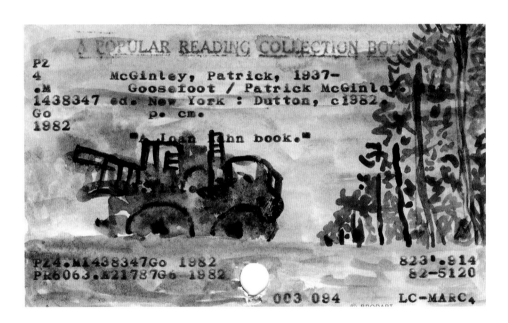

48. *GARDEN TRUCK*, 2006, PEN AND INK ON LIBRARY CATALOGUE CARD, 3 X 5 IN.

49. *GOOSE FOOT*, 2009, WATERCOLOR ON LIBRARY CATALOGUE CARD, 3 X 5 IN.

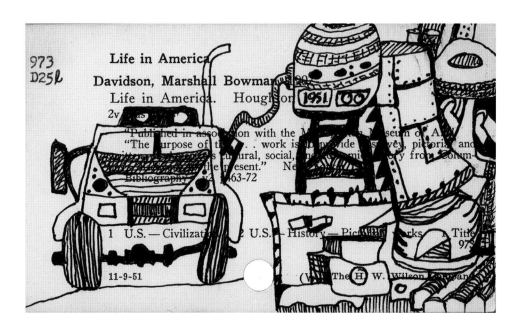

50. *LIFE IN AMERICA*, 2003, PEN AND INK ON LIBRARY CATALOGUE CARD, 3 x 5 IN.

51. *PERSONAL NARRATIVES*, 2009, WATERCOLOR ON LIBRARY CATALOGUE CARD, 3 x 5 IN.

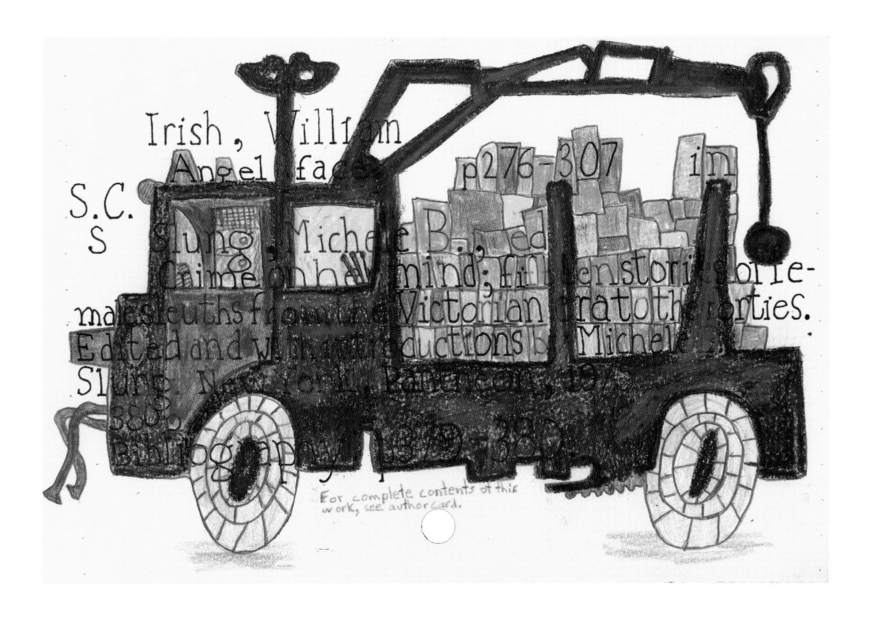

Irish, William
Angel face p276-307 in
S.C.
S Slung, Michele B., ed
 Crime on her mind; fifteen stories of fe-
male sleuths from the Victorian era to the forties.
Edited and with introductions by Michele
Slung. New York, Pantheon, 1975
388p
Bibliography p379-388

For complete contents of this
work, see author card.

52. *ANGEL FACE*, 2005, COLORED PENCIL ON PAPER, 7½ X 11 IN.

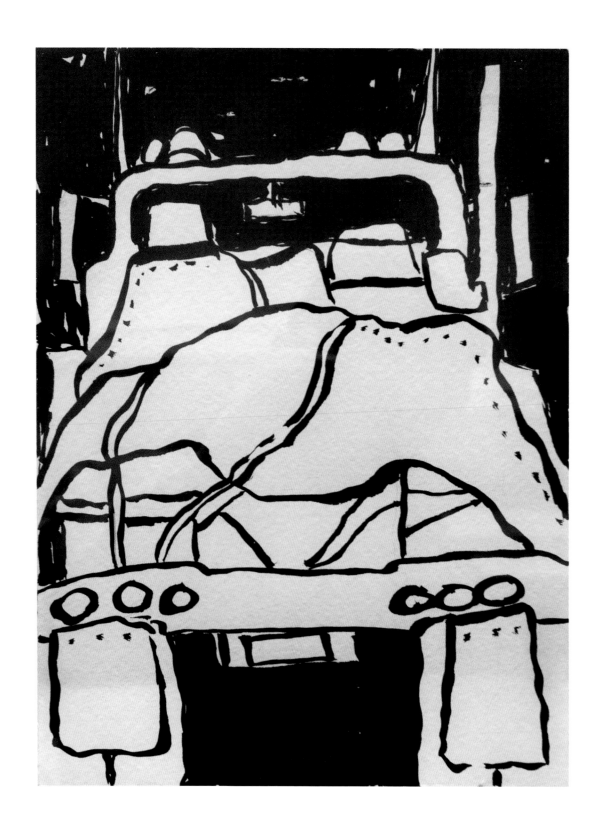

53. *I-80 LANDSCAPE*, 1984, BRUSH AND INK ON PAPER, 12 x 9 IN.

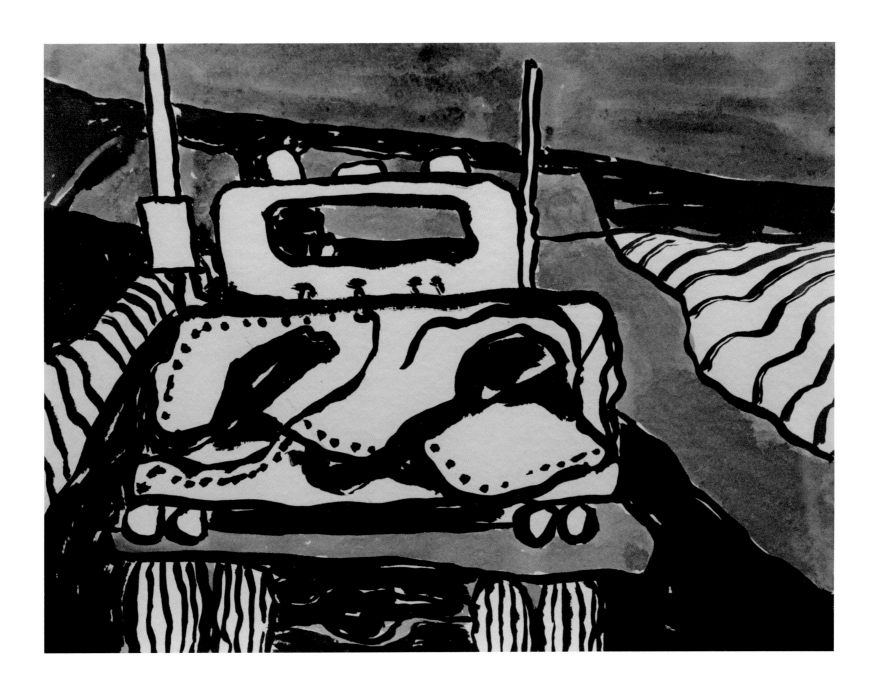

54. *I-80 OMAHA RUN*, 1984, BRUSH AND INK ON PAPER, 9 x 12 IN.

55. *GARCIA MADERO*, 2010, PEN AND INK ON JAPANESE PAPER, 18¼ x 25⅜ IN.

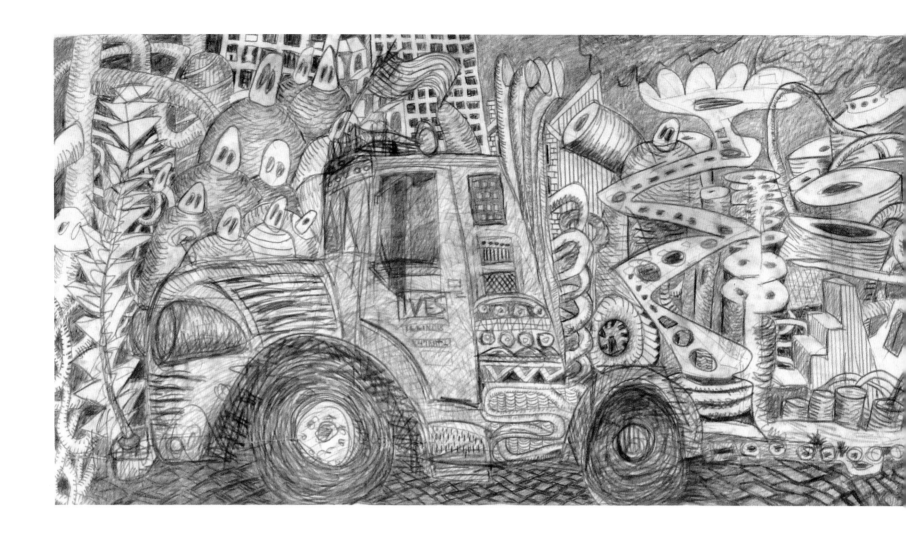

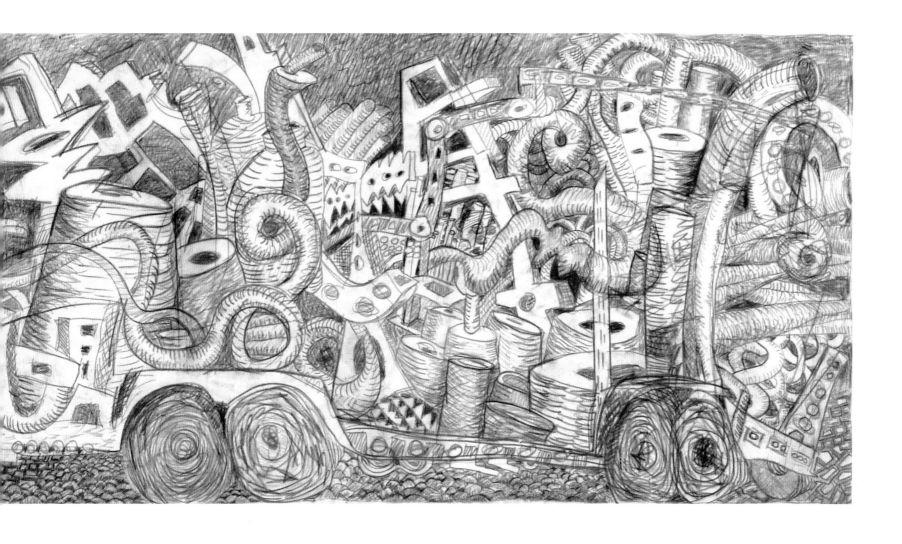

56. *TEMPERANCE*, 2006, GRAPHITE ON RAW COTTON CANVAS, 40 x 138 IN.

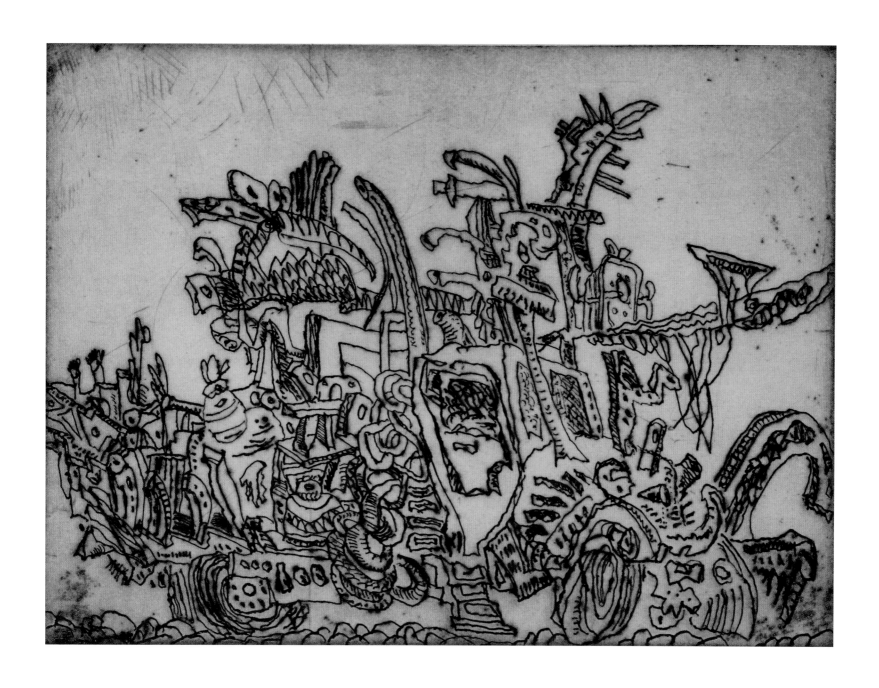

57. *ACTOR*, 2011, ETCHING, 14 x 16 IN.

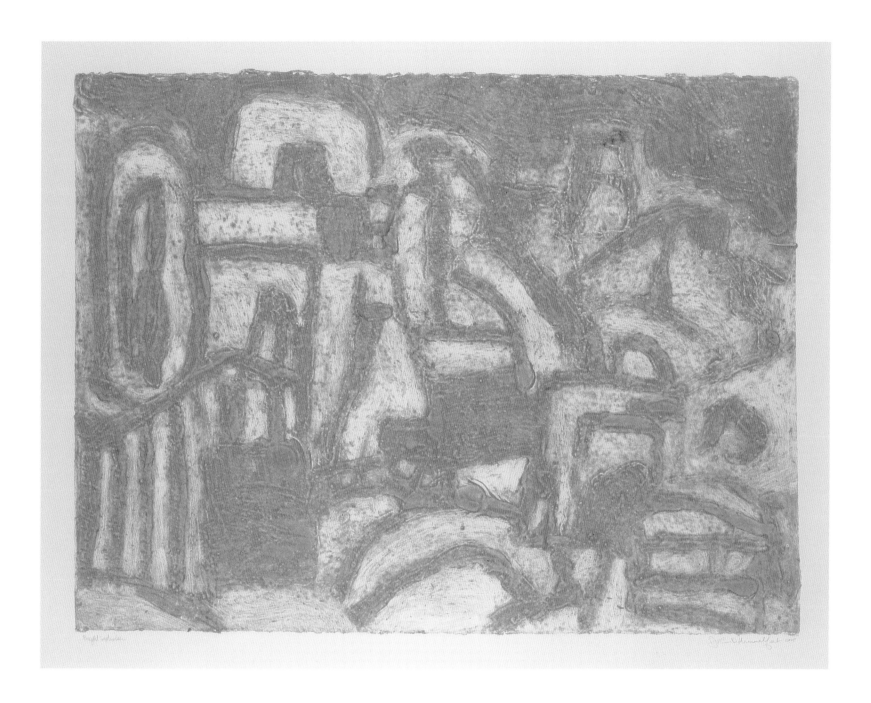

58. *BRIGHT SEPTEMBER*, 2008, COLLAGRAPHIC MONOPRINT, 29½ x 41½ IN.

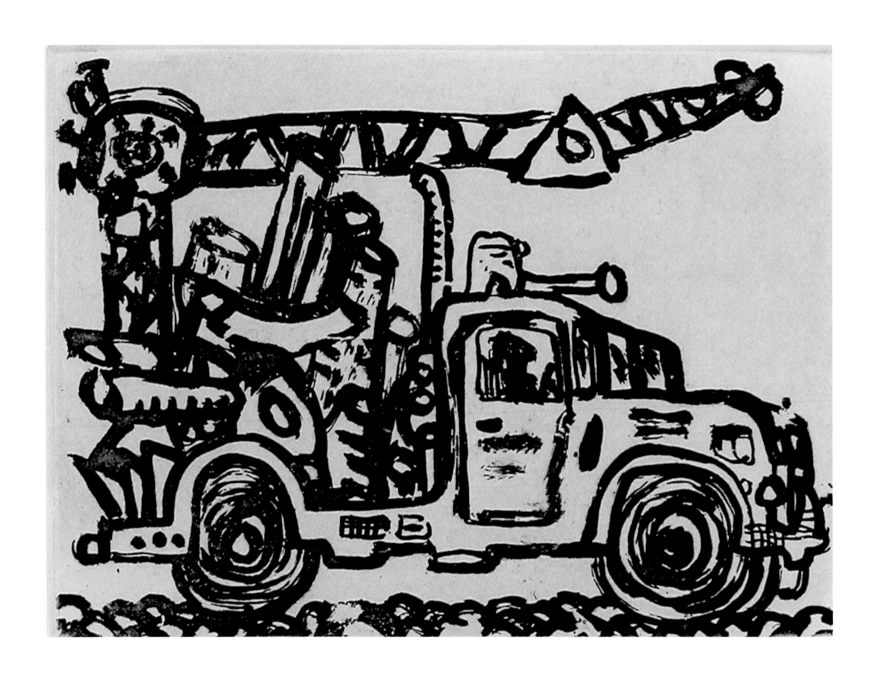

59. *COMBO*, 2006, ETCHING, 10 x 10 IN

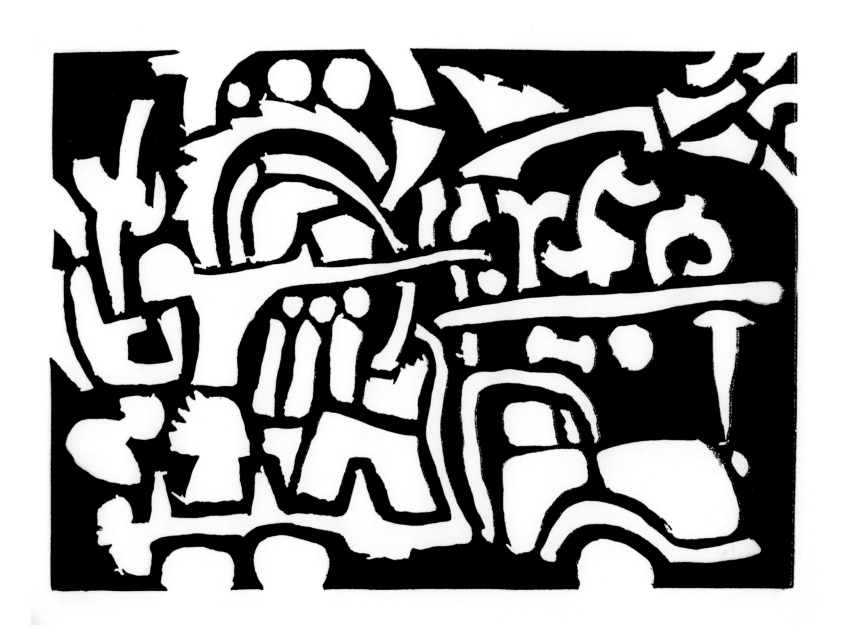

60. *DRIFT ICE*, 2009, PLASMA CUT ALUMINUM RELIEF, 19 x 26 IN.

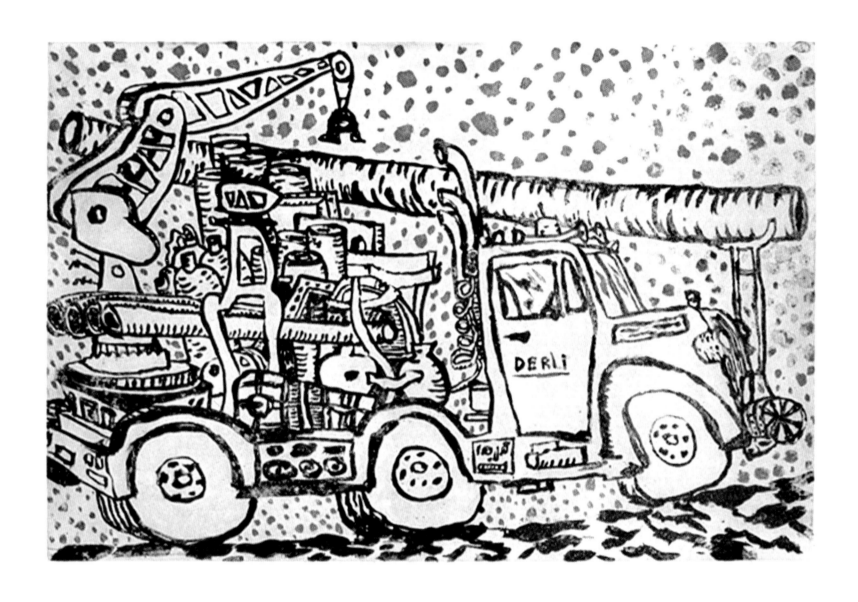

61. *HECTOR IN ZAMORA*, 2006, ETCHING, 16 x 24 IN.

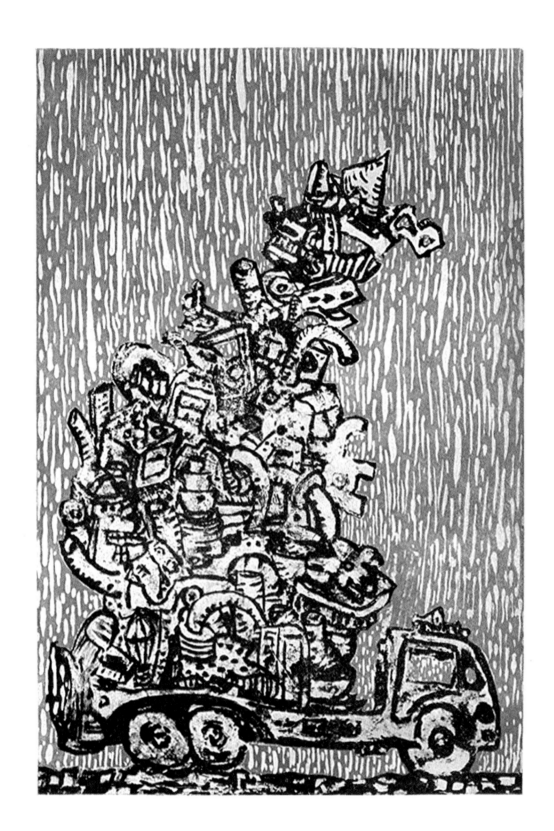

62. *NATURALEZA MUERTA*, 2006, ETCHING, 24 x 16 IN.

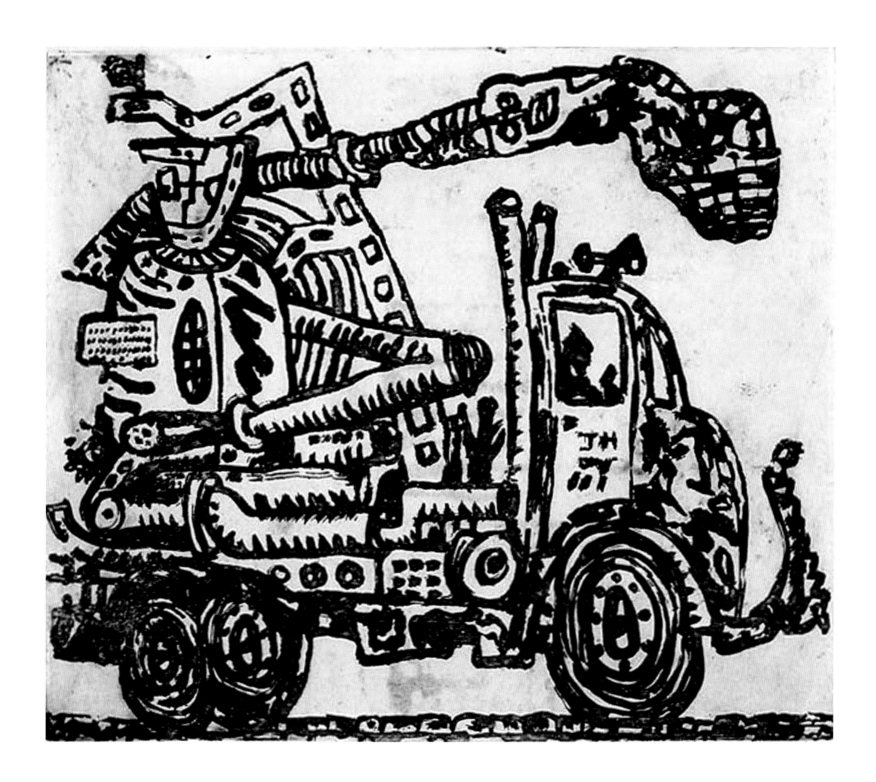

63. *MISSION*, ETCHING, 2006, 15 x 15 in.

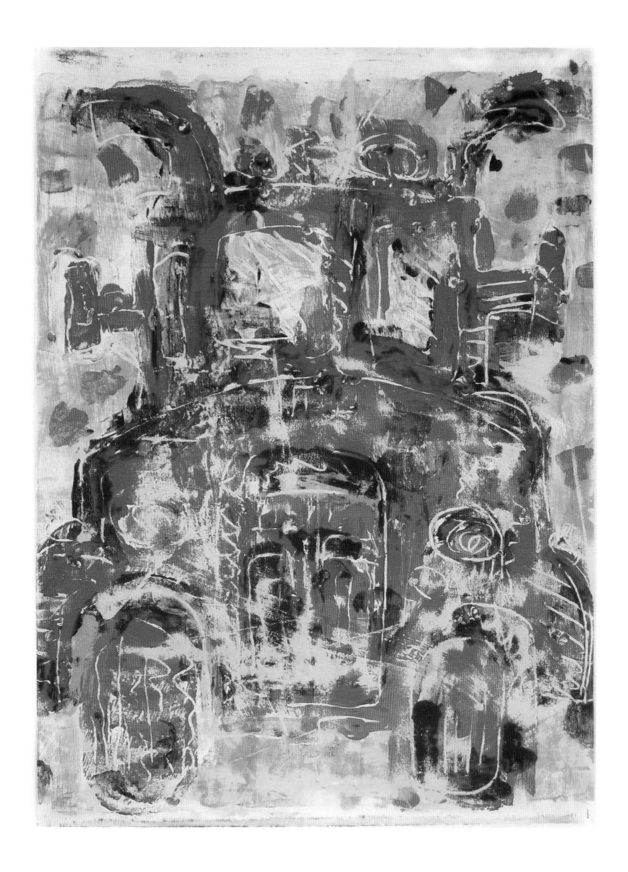

64. *NEW YEAR TRUCK*, 2007, CLAY MONOTYPE ON PELLON, 30 x 22 IN.

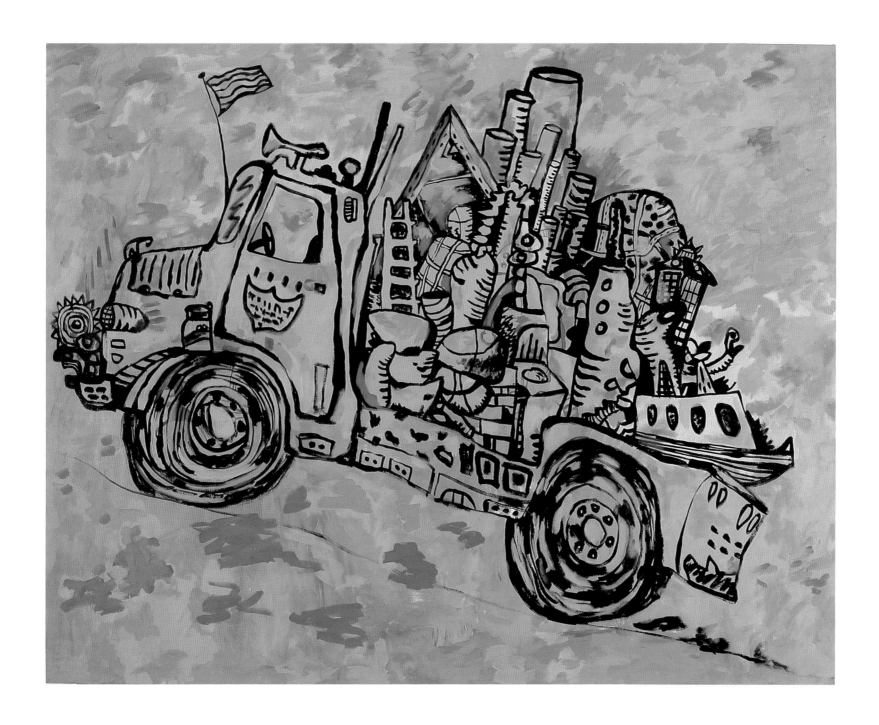

65. *ASPIRATION*, 2005, ACRYLIC ON CANVAS, 66 x 84 IN.

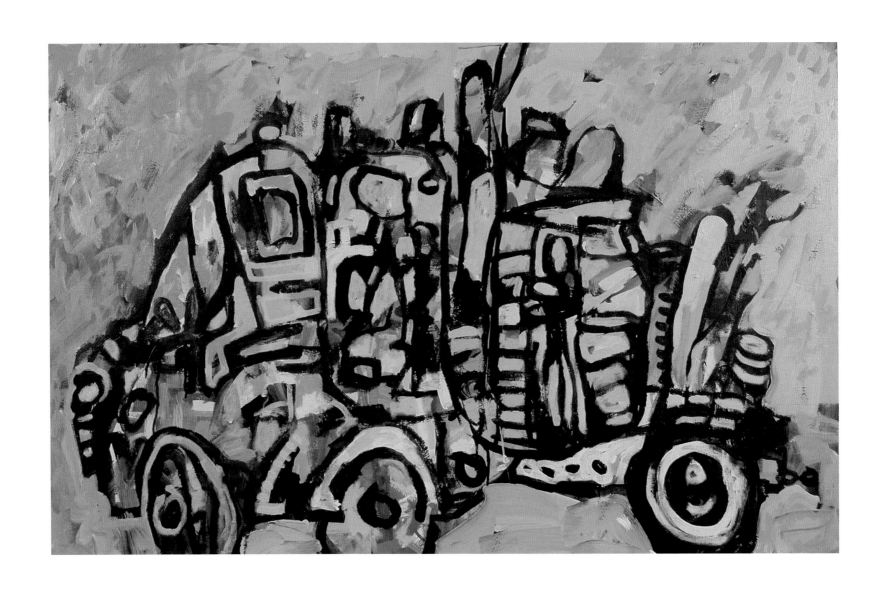

66. *BATEAU*, 2005, ACRYLIC ON CANVAS, 38 IN. X 60 IN.

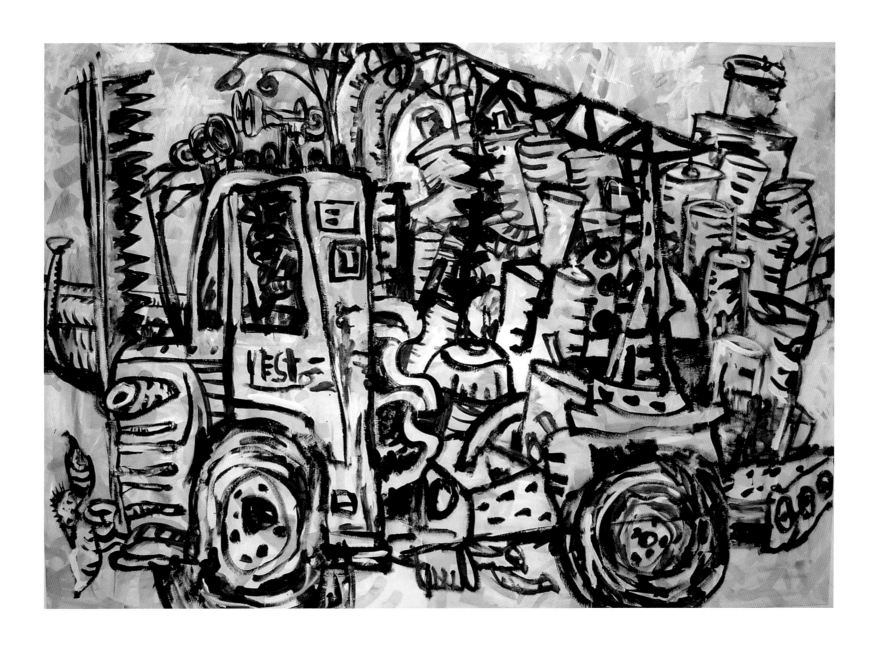

67. *CHASTITY*, 2006, ACRYLIC ON CANVAS, 56 X 81 IN.

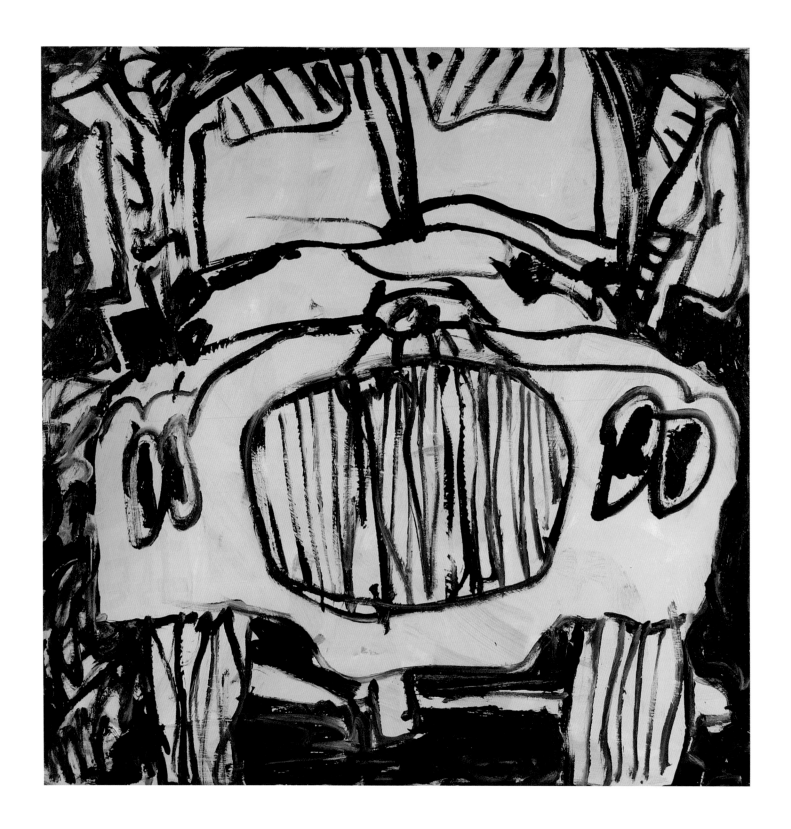

68. *CRISIS MANAGEMENT*, 2008, ACRYLIC ON CANVAS, 48 x 48 IN.

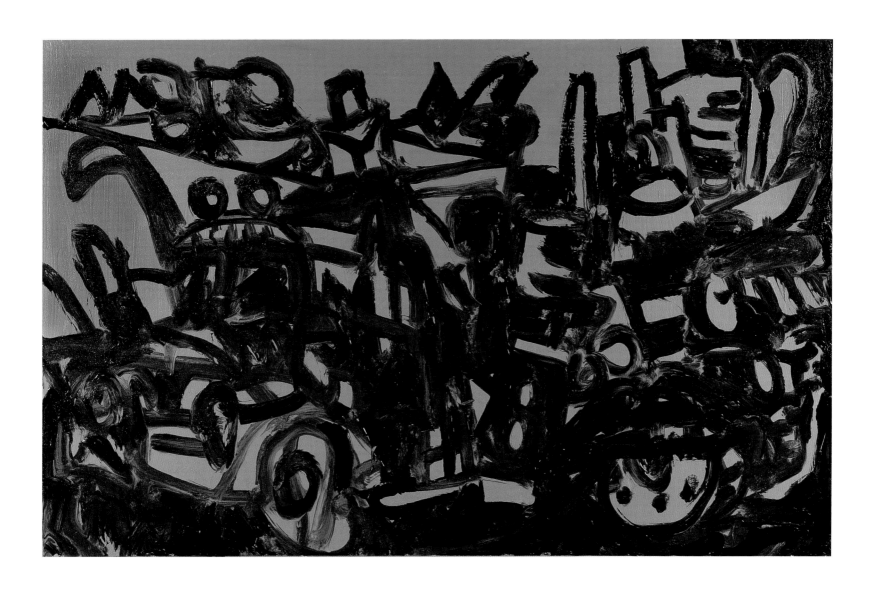

69. *DUG IN*, 2008, ACRYLIC ON CANVAS, 38 X 60 IN.

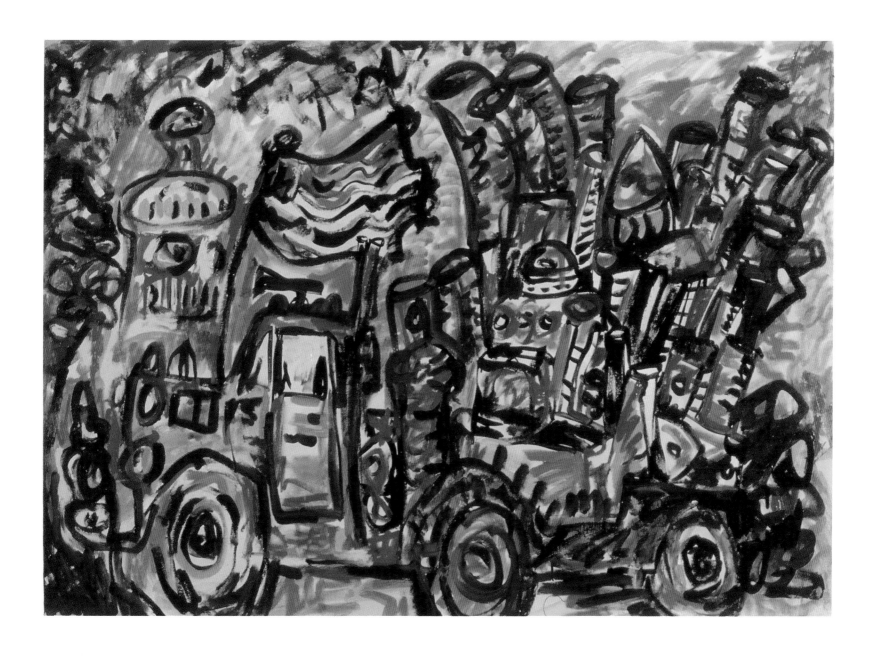

70. *HOPE*, 2006, ACRYLIC ON CANVAS, 38 x 60 IN.

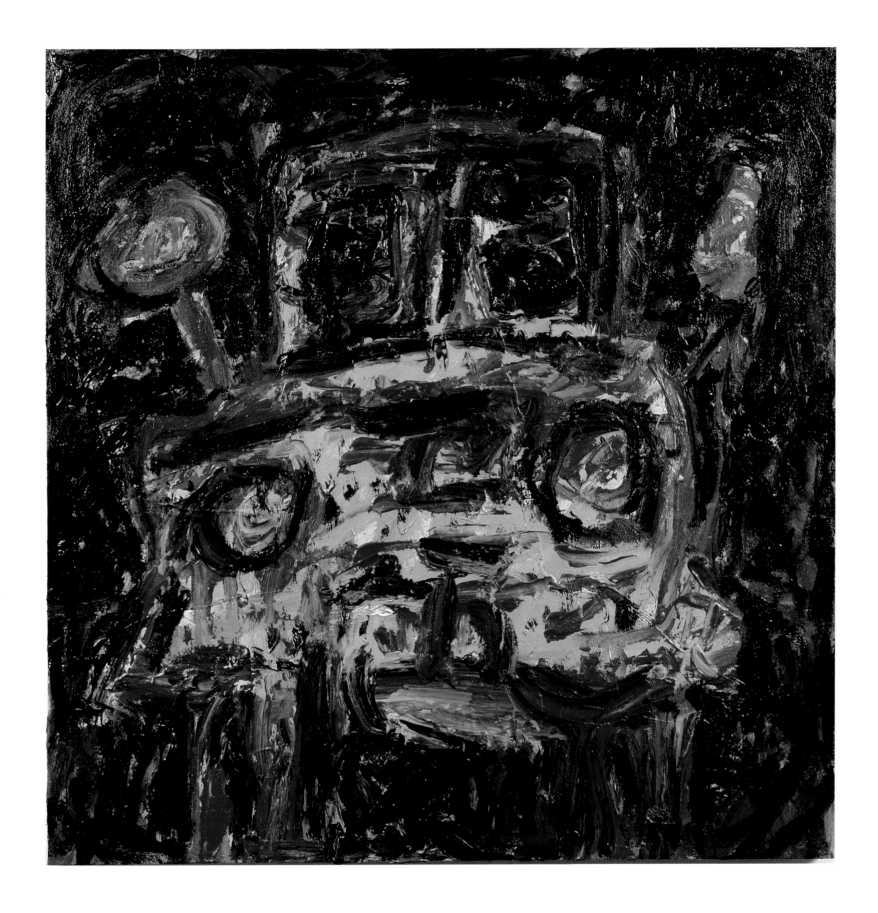

71. *GOING HOME*, 2007, ACRYLIC ON CANVAS, 36 X 36 IN.

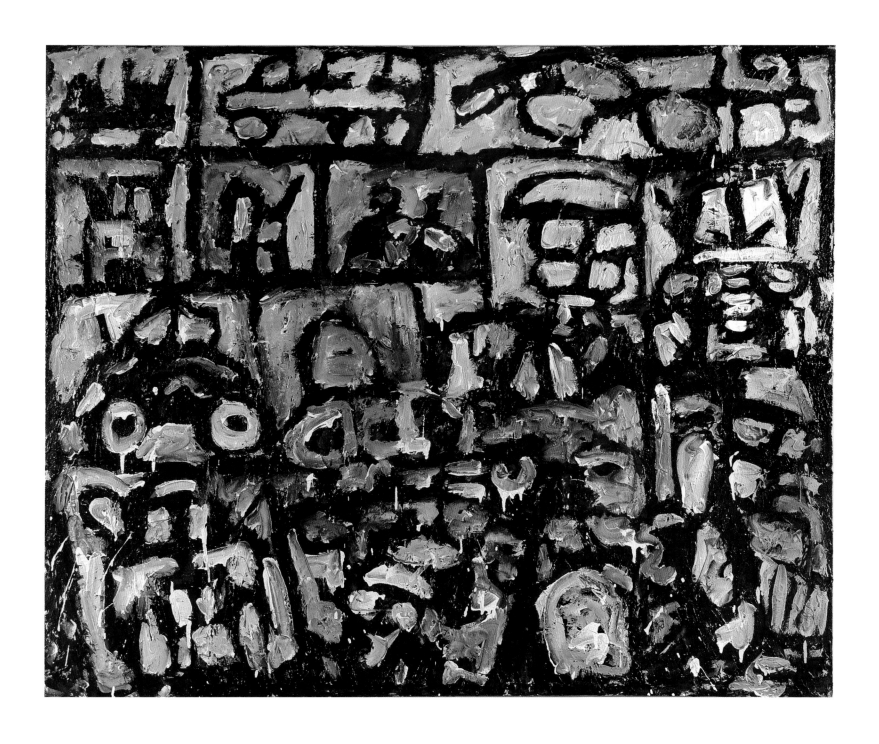

72. *INVENTORY*, 2008, ACRYLIC ON CANVAS, 48 x 60 IN.

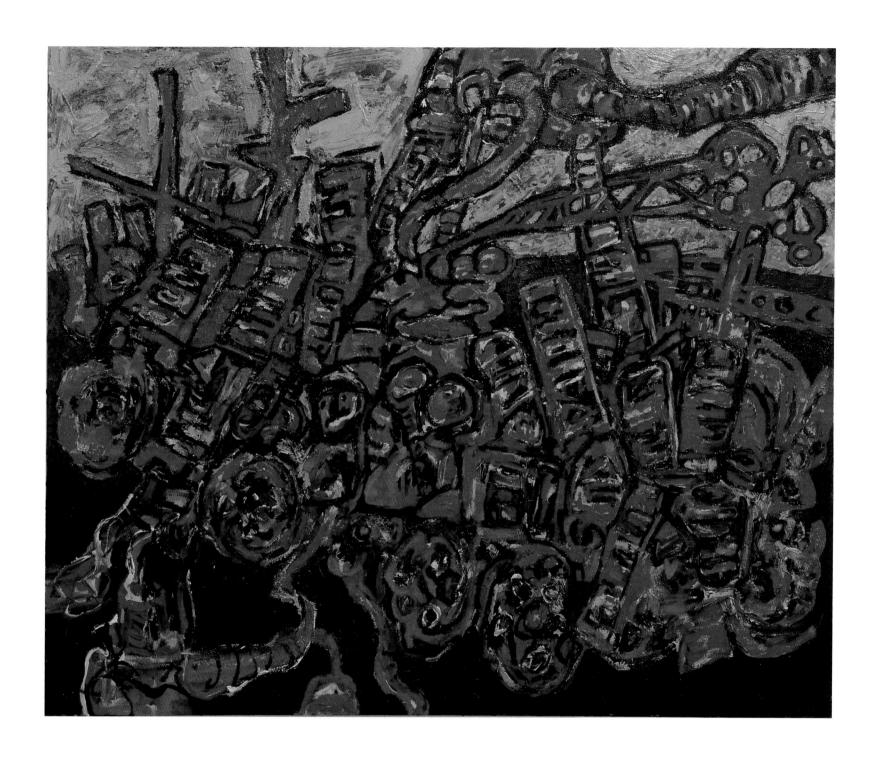

73. *JUGGERNAUT*, 2010, ACRYLIC ON CANVAS, 60 x 72 IN.

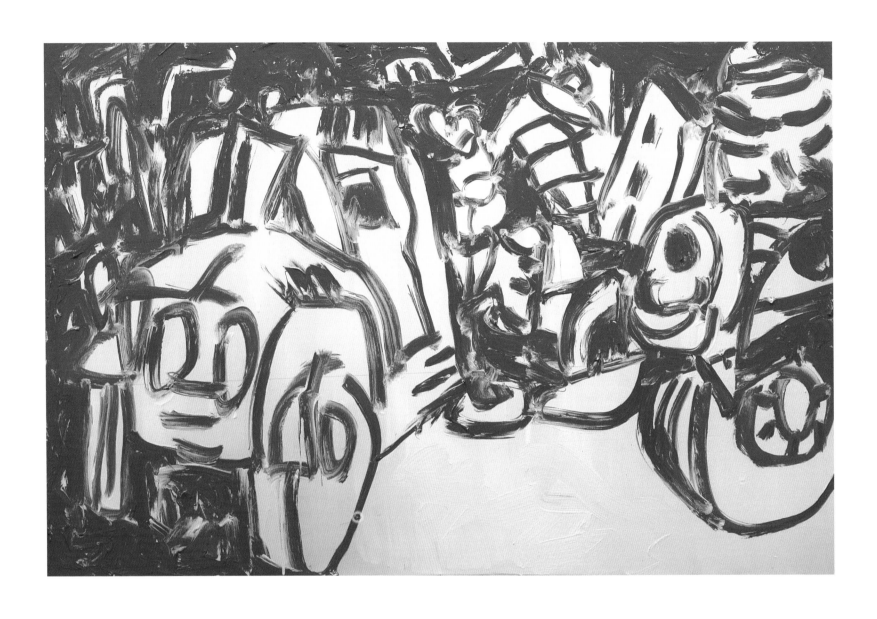

74. *REVOLUTION*, 2008, ACRYLIC ON CANVAS, 44 X 68 IN.

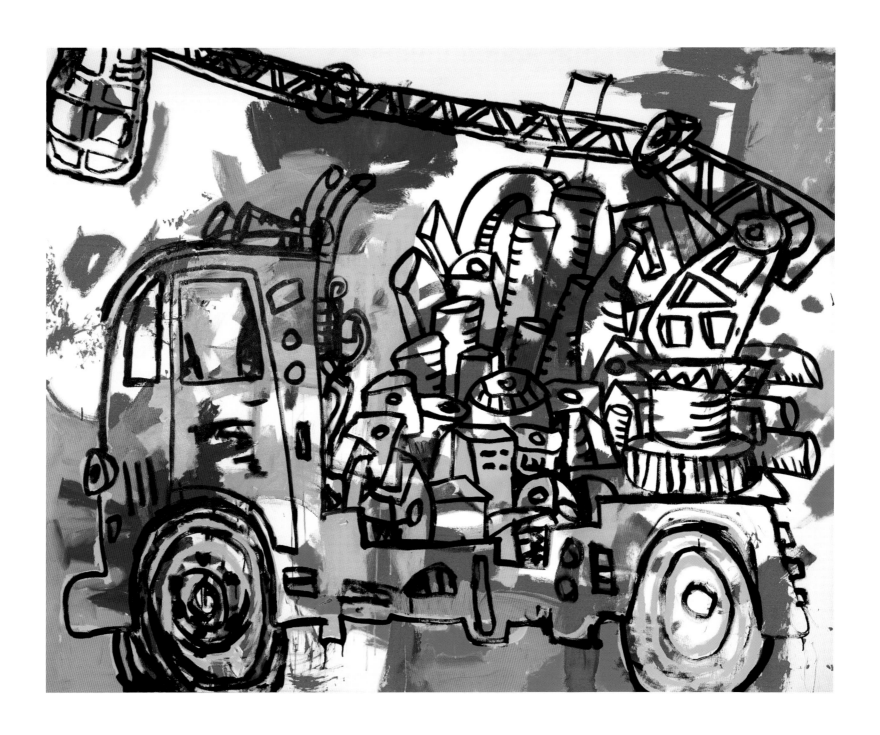

75. *RESURRECTION*, 2006, ACRYLIC ON CANVAS, 66 X 84 IN.

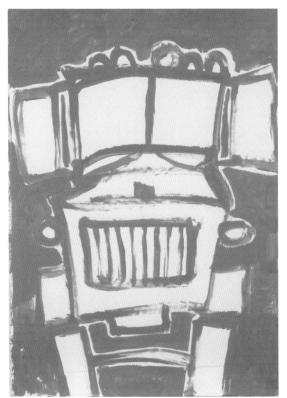

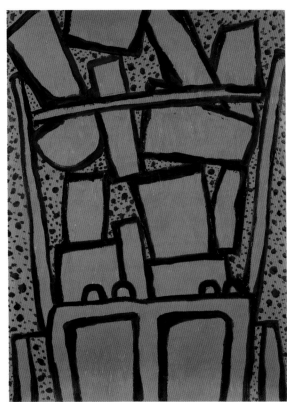

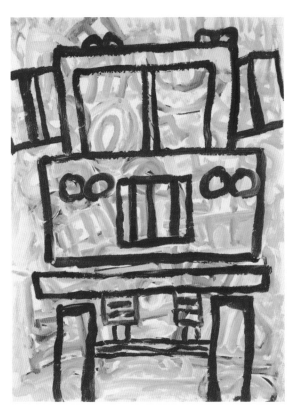

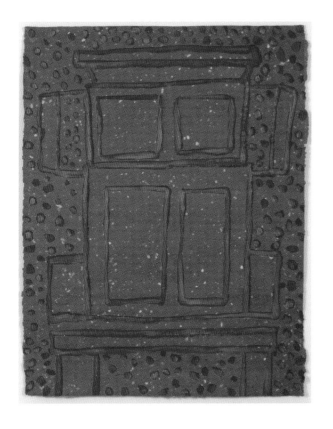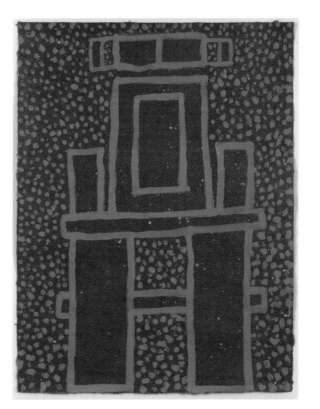

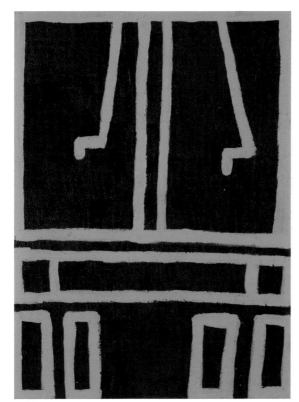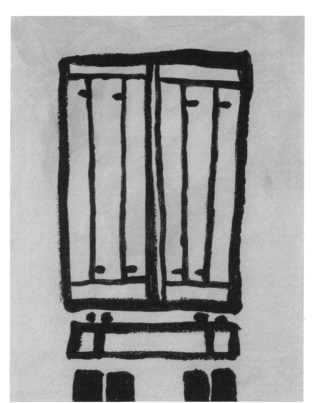

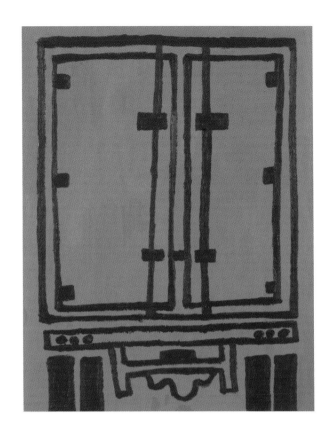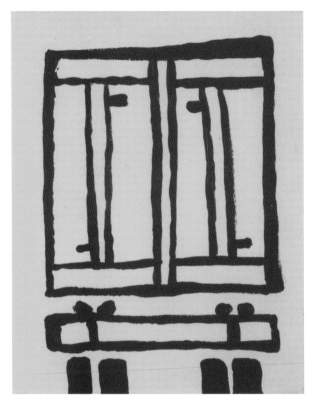
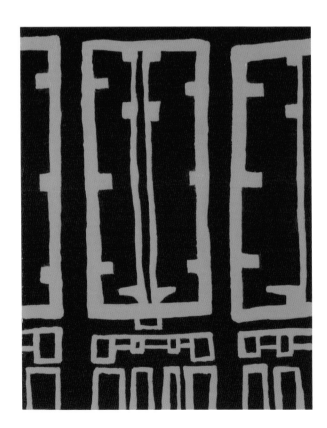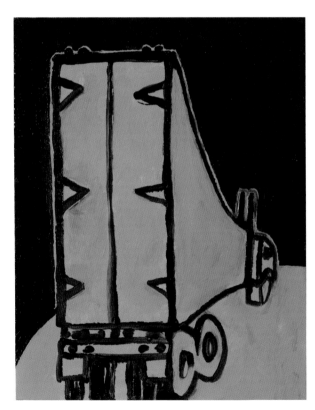

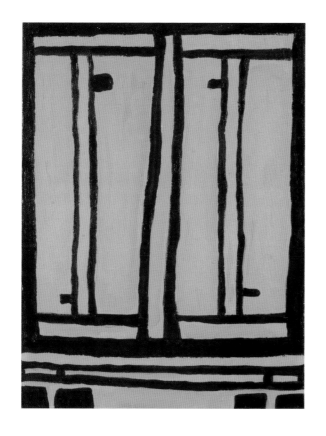

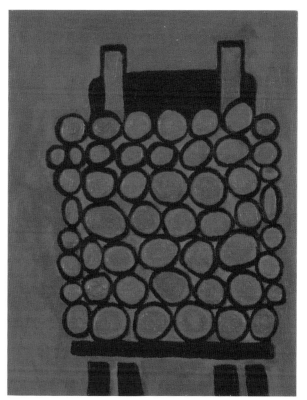

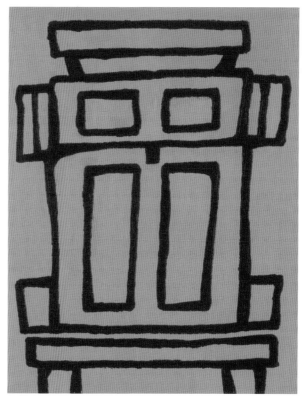

Previous spreads (clockwise, top left):

76–79.
PV#1, 2013, PAINTING ON PAPER, 30¼ x 21½ IN.
PV#4, 2013, PAINTING ON PAPER, 30¼ x 21¼ IN.
PV#3, 2013, PAINTING ON PAPER, 29⅞ x 22 IN.
PV#2, p2013, PAINTING ON PAPER, 29⅞ x 22 IN.

80–83.
PV#5, 2013, PAINTING ON PAPER, 25¾ x 20 IN.
PV#6, 2013, PAINTING ON PAPER, 25¾ x 20 IN.
PV#9, 2013, PAINTING ON CANVAS BOARD, 14 x 11 IN.
PV#8, 2013, PAINTING ON CANVAS BOARD, 14 x 11 IN.

84–87.
PV#22, 2013, PAINTING ON CANVAS BOARD, 18 x 14 IN.
PV#12, 2013, PAINTING ON CANVAS BOARD, 14 x 11 IN.
PV#14, 2013, PAINTING ON CANVAS BOARD, 14 x 11 IN.
PV#13, 2013, PAINTING ON CANVAS BOARD, 14 x 11 IN.

88–91.
PV#18, 2013, PAINTING ON CANVAS BOARD, 16 x 12 IN.
PV#21, 2013, PAINTING ON CANVAS BOARD, 18 x 14 IN.
PV#23, 2013, PAINTING ON CANVAS BOARD, 18 x 14 IN.
PV#20, 2013, PAINTING ON CANVAS BOARD, 16 x 12 IN.

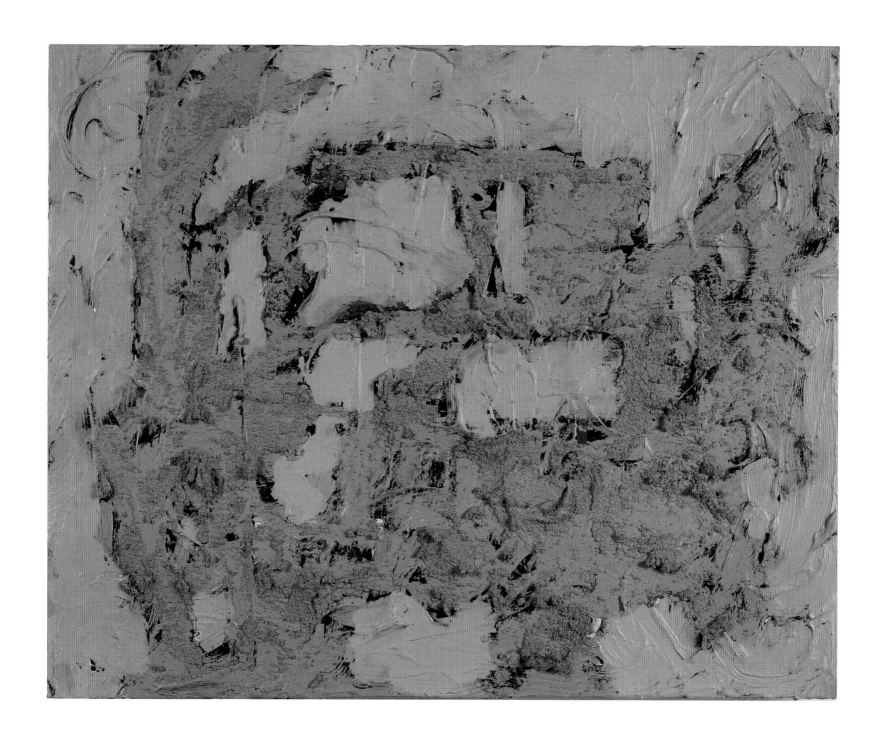

92. *WRECKER*, 2008, ACRYLIC ON CANVAS, 16 x 20 IN.

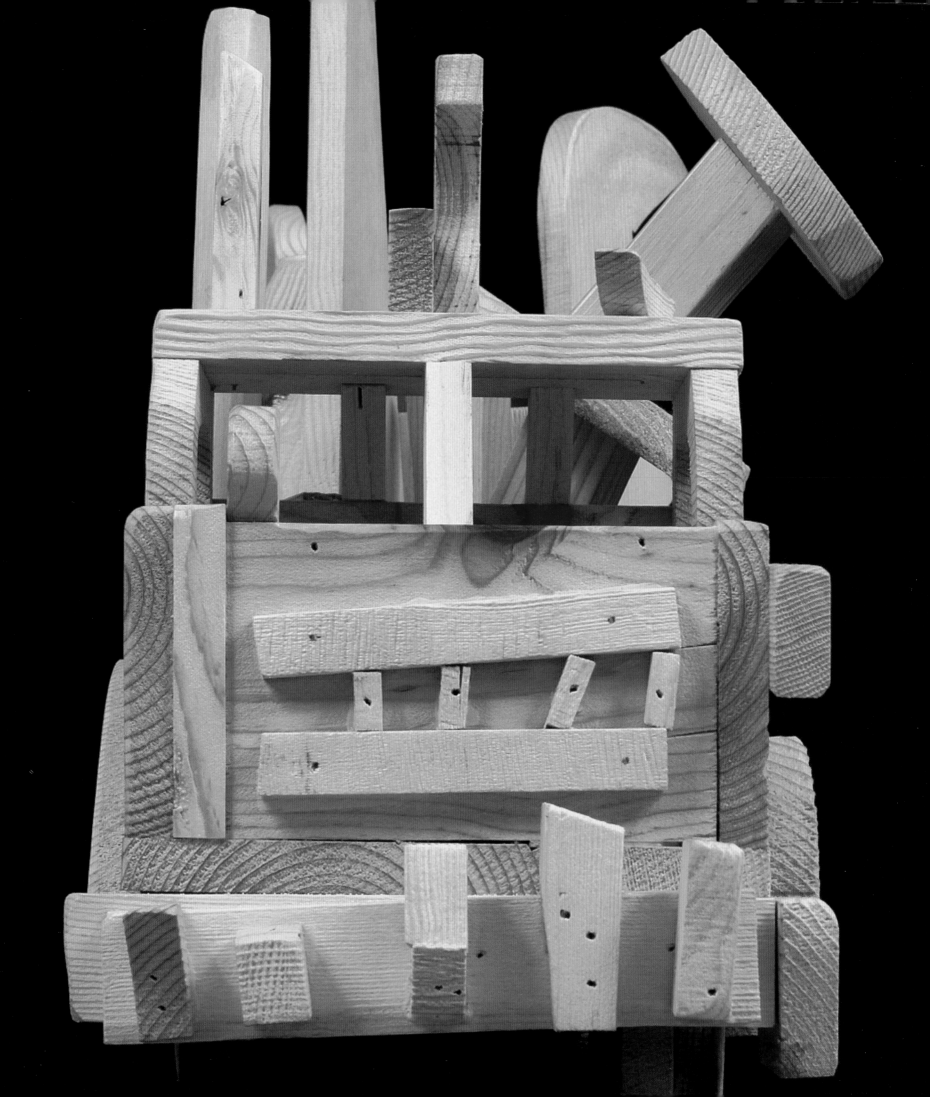

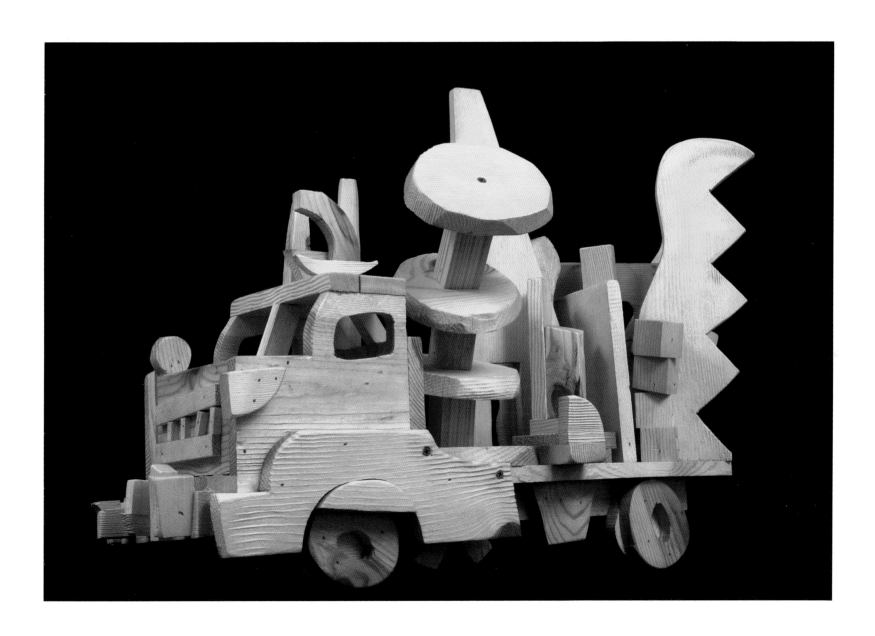

93 AND 94. ARKANSAS TRAVELER, 2010, PINE, 20 X 34 X 10 IN. IN COLLABORATION WITH MAC HORNECKER.

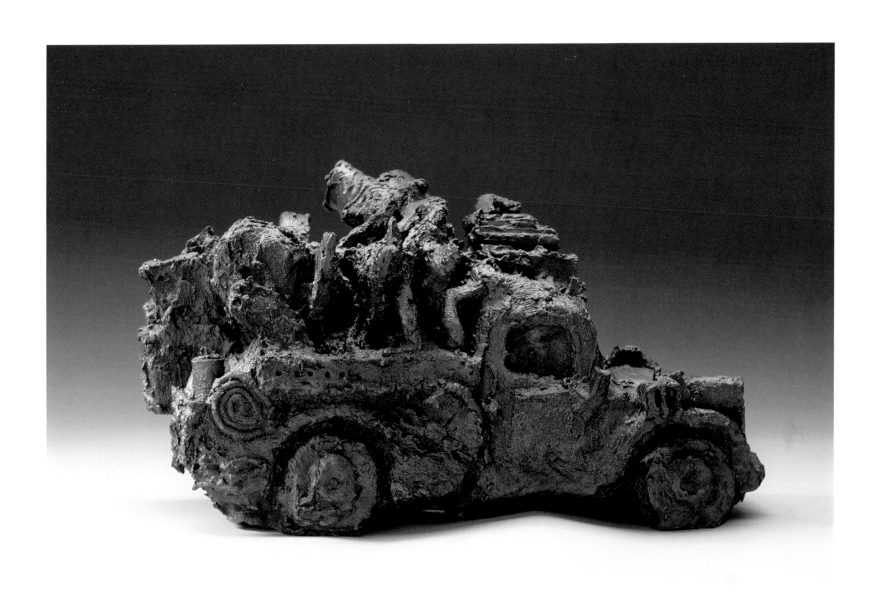

95. *ENGINE NO. 1*, 2007, CAST IRON, 12½ x 23 x 11¼ IN.

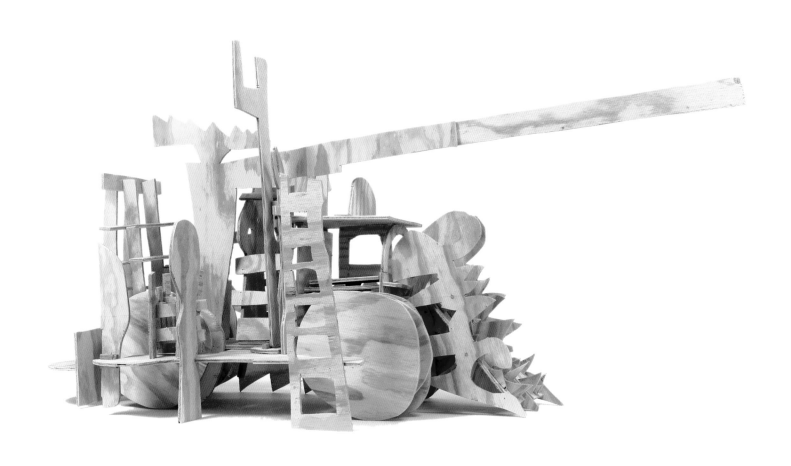

96. *GEARED UP*, 2010, WOOD, 29 x 61 x 22 IN.

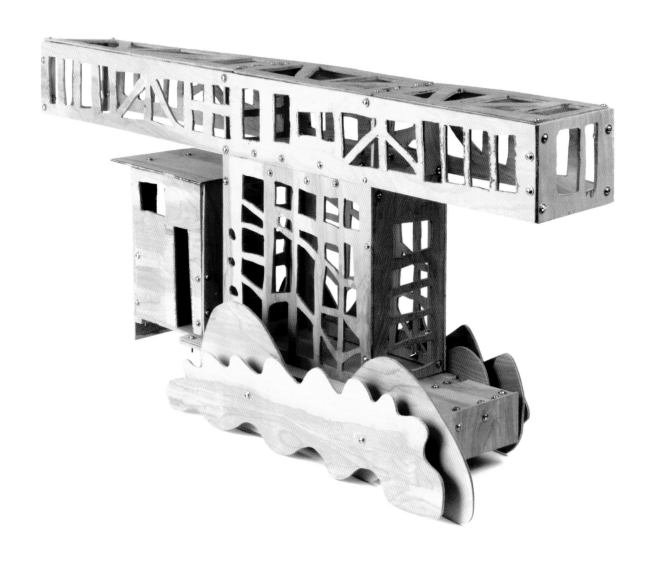

97. *GIRDER*, 2012, PLYWOOD, NUTS AND BOLTS, 21½ x 48 x 12 IN.

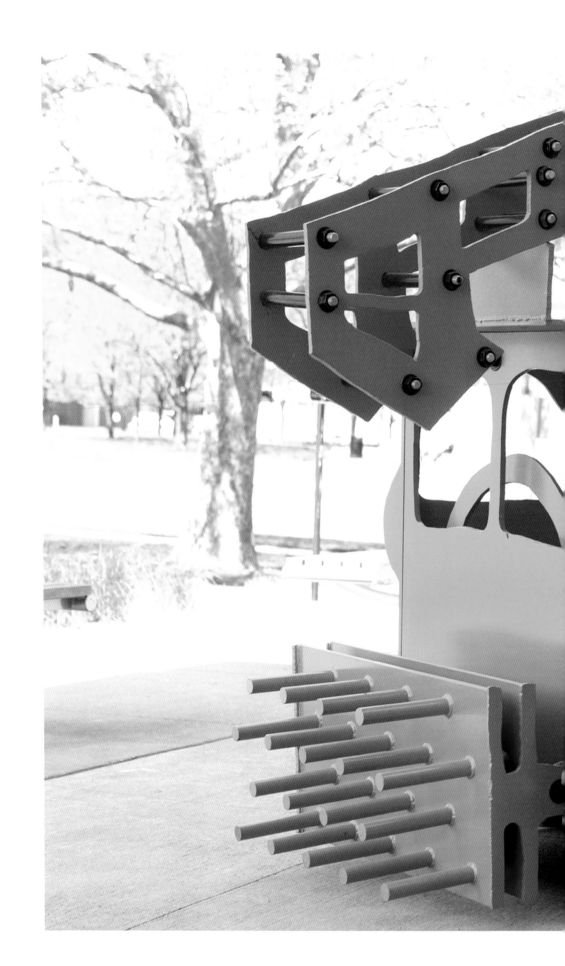

98. *THE ROAD AHEAD LEAVES A TRAIL BEHIND*, 2012, PAINTED STEEL,
6 x 10 x 3 FT. IN COLLABORATION WITH STEVE MUELLER.

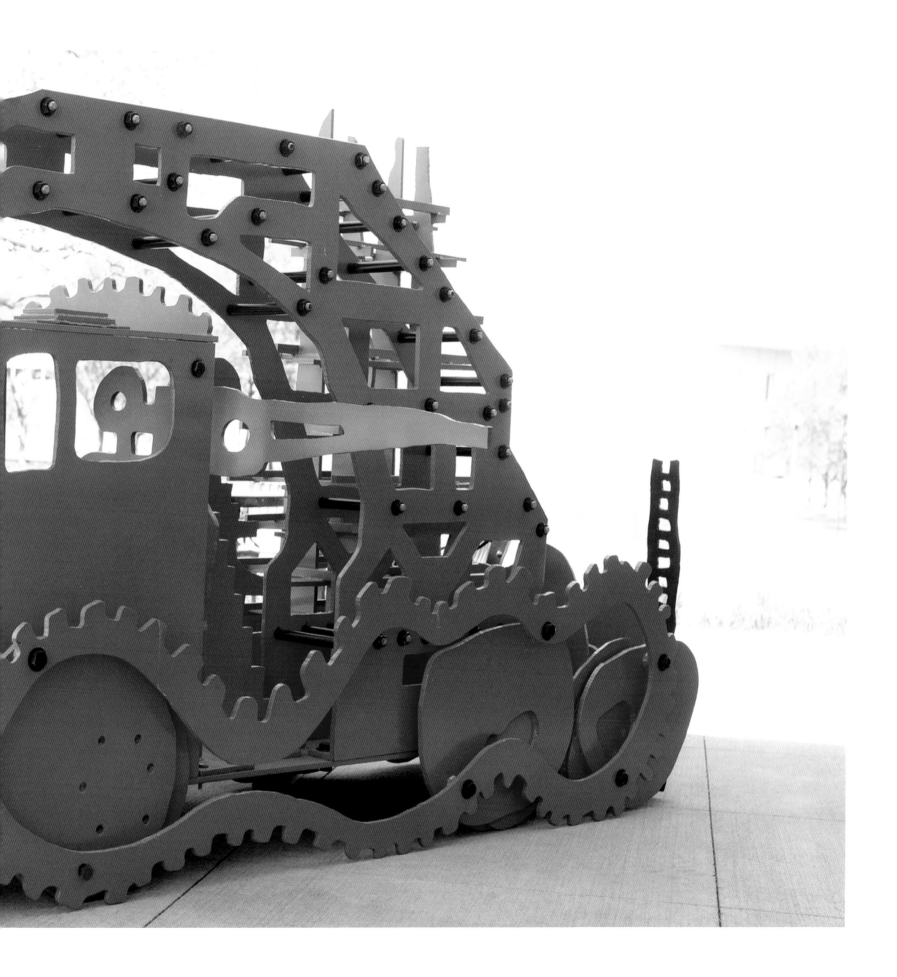

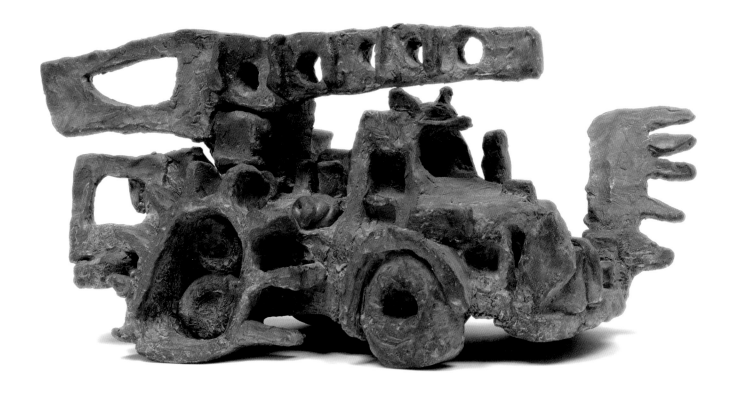

99. *FORTITUDE*, 2010, BRONZE, EDITION OF 3, 7 ½ X 16 X 9 IN.

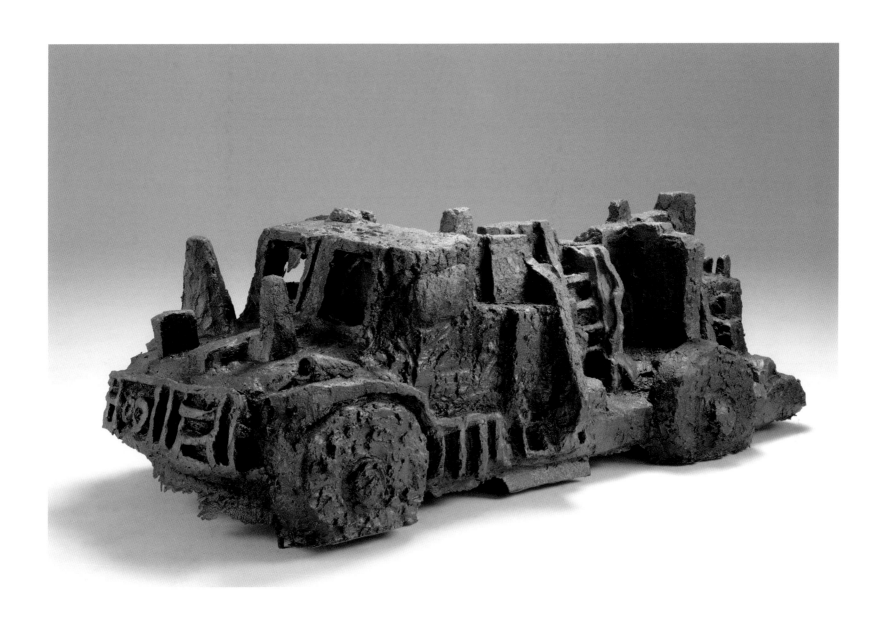

100. *GREEK OPERA*, 2007, CAST IRON, 22½ × 72 × 30 IN.

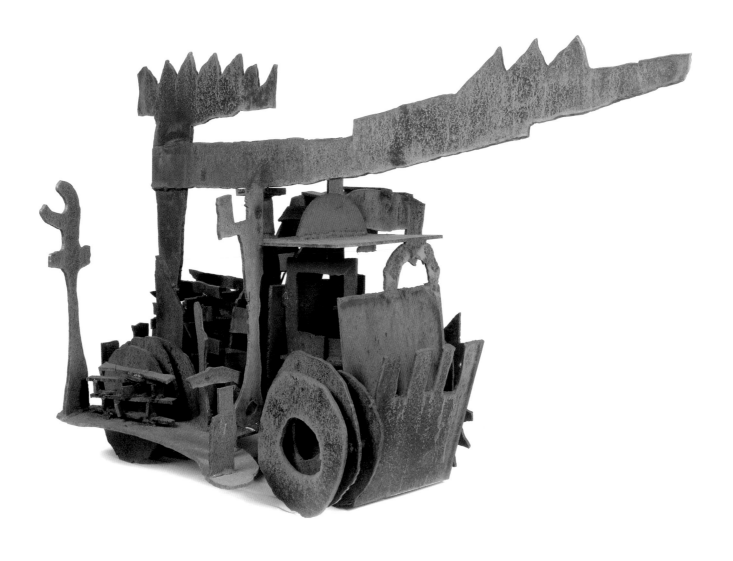

101. *HONOR*, 2011, UNPAINTED STEEL PLATE, 32 x 60 x 34 IN.

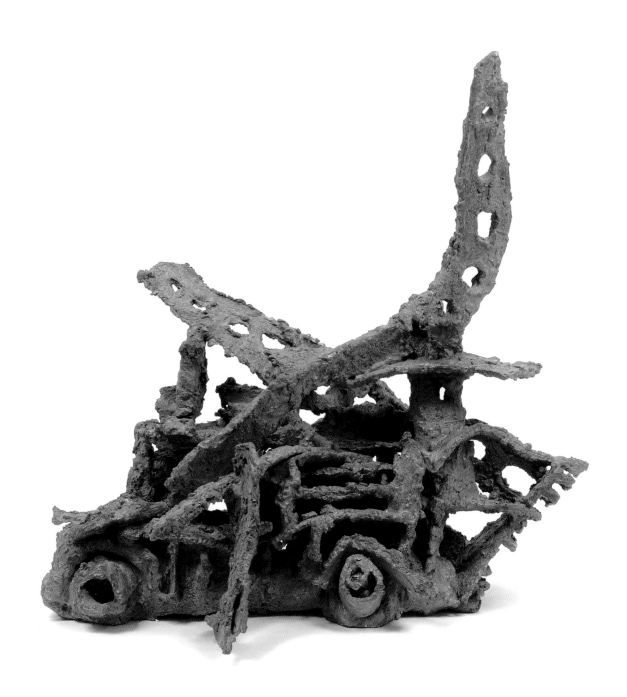

102. *KNOWLEDGE*, 2009, BRONZE, 27 X 31 X 22 IN.

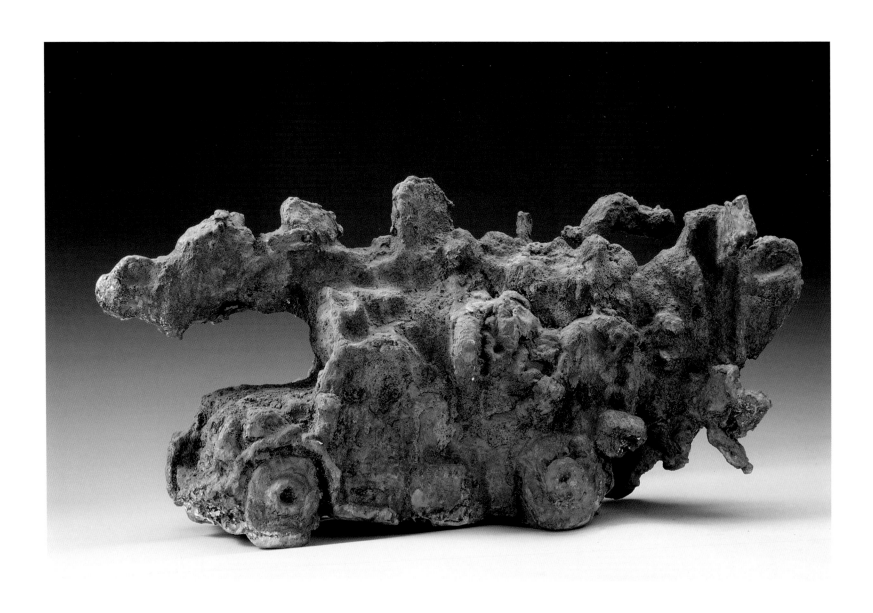

103. *REEFER*, 2007, BRASS, 14¾ x 30½ x 9 IN.

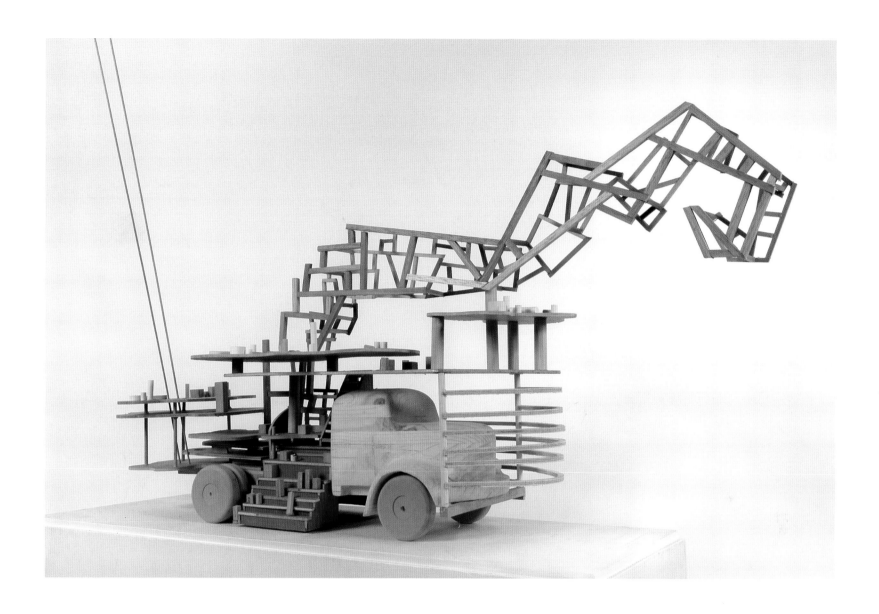

104. *REO SPEEDWAGON MODEL NO. 1*, 2009, WOOD, 42 x 50 x 23 IN.

JOHN HIMMELFARB

Born in Chicago in 1946, John Himmelfarb grew up in a rural area west of Chicago in the late 1940s and '50s with his two artist parents, Sam and Eleanor Himmelfarb. While engaged in the arts as a youth, he did not turn to the visual arts as a career until late in his college experience at Harvard University in Cambridge, Massachusetts. He has had a studio in Chicago since 1970 and has shown frequently in New York, Chicago, and throughout the country since the 1970s. His work is in numerous museum collections, including the British Museum, London, England; Museum of Modern Art, New York; the Brooklyn Museum, Brooklyn, NY; Smithsonian American Art Museum, Washington, DC; The Art Institute of Chicago; and many others. He continues to maintain studios in Chicago, Illinois as well as Spring Green, Wisconsin.

Published on the occasion of the exhibition *Trucks: Recent Work by John Himmelfarb*, on view at Brauer Museum of Art at Valparaiso University, Valparaiso, Indiana from January 7 to April 6, 2014; Jule Collins Smith Museum of Fine Art, Auburn, Alabama from September 1, 2014 to January 1, 2015; and Amarillo Museum of Art, Amarillo, Texas from May 15– August 1, 2015.

Related Solo Exhibitions

2015 *Trucks: Recent Work by John Himmelfarb*, Amarillo Museum of Art, Amarillo, TX

2014–
2015 *Trucks: Recent Work by John Himmelfarb*, Jule Collins Smith Museum
of Fine Art, Auburn, AL

2014 *Trucks: Recent Work by John Himmelfarb*, Brauer Museum of Art at Valparaiso
University, Valparaiso, IN

2013 *Why Trucks?*, Indianapolis University, Indianapolis, IN

2012 *Thirty Years, Shifting Gears*, Luise Ross Gallery, New York, NY

John Himmelfarb, Paintings and Sculpture, Modern Arts Midtown, Omaha, NE

2011 *Driven: New Trucks by John Himmelfarb*, Chicago Cultural Center, Chicago, IL
John Himmelfarb, Metropolitan Capital Bank, Chicago, IL

Built from Similar Parts: Paintings, Drawings, Prints and Sculptures,
River Gallery, Chelsea, MI

2010 *Geared Up*, Luise Ross Gallery, New York, NY

2009 *A Circulating Library: John Himmelfarb Selected Works*, H.F. Johnson Gallery
of Art, Carthage College, Kenosha, WI

Conversion, Vector Custom Fabricating, Chicago, IL

2008 *John Himmelfarb*, Gallery 72, Omaha, NE

Multi-Dimensional: John Himmelfarb, FLATFILE Galleries, Chicago, IL

Related Group Exhibitions

2013 *Metro Fair*, Luise Ross Gallery, New York, NY

Farm Art Dtour, Reedsburg WI

2012 *TURF*, an IDADA installation Super Bowl event, Indianapolis, IN

2011 *Sculpture for the Home*, Northern Illinois University Art Museum, DeKalb, IL

Fall Prints, IPCNY, New York, NY

Multiple Propositions, Herron School of Art and Design, Indianapolis, IN

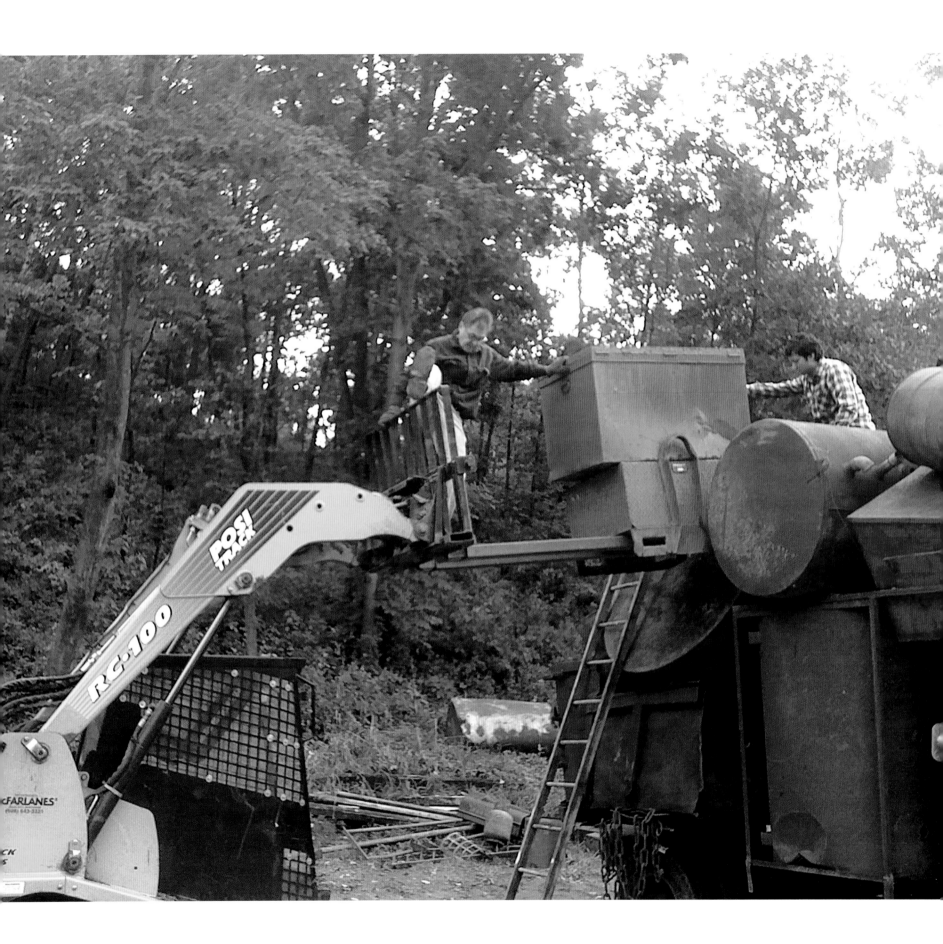

CREDITS

John Himmelfarb's work is represented by Luise Ross, New York, and Modern Arts Midtown, Omaha.

Page 1 Photo Miles Votek. Page 2–3 Photo Steve Mueller. Page 4 Photo Daniel Marquardt. Page 6–7 Photo Molly Day. Page 8 Photo Daniel Marquandt. Page 10 Photo Duk Ju Kim. Page 13 (top) Photo Miles Votek; (bottom): Molly Day. Page 14 Photo Molly Day. Page 16 Photo Darren Parker. Page 20 Photo John Himmelfarb. Page 26 Photo Rich Maciejewski. Courtesy of the John Michael Kohler Arts Center and Kohler Co. Page 42 Photo Steve Mueller. Page 134 Photo Molly Day.

1. Photo William H. Bengtson.

2. Photo William H. Bengtson.

3. Photo William H. Bengtson.

4. Photo Sarah Neighbors. Courtesy McNutt Gallery.

5. Photo William H. Bengtson.

6. Photo William H. Bengtson. Collection South Central Bank, 160 N. Morgan, Chicago, IL 60607.

7. Photo Logan Roots, Modern Arts Midtown

8. Photo William H. Bengtson.

9. Photo William H. Bengtson. Collection Karen and Robert Duncan, Lincoln, NE.

10. Photo William H. Bengtson.

11. Photo William H. Bengtson.

12. Photo William H. Bengtson.

13. Photo William H. Bengtson.

14. Photo William H. Bengtson.

15. Photo William H. Bengtson. Katz Family Collection, Tiburon, CA.

16. Photo William H. Bengtson.

17. Photo William H. Bengtson. Private Collection

18. Photo William H. Bengtson.

19. Photo William H. Bengtson. Private Collection.

20. Photo William H. Bengtson. Collections of Michael and Elaine Bennett, DeKalb, IL; Karen and Robert Duncan, Lincoln, NE; Sara Foxley, Omaha, NE.

21. Photo William H. Bengtson. Katz Family Collection, Tiburon, CA.

22. Photo Rich Maciejewski. Courtesy of the John Michael Kohler Arts Center and Kohler Co.

23. Photo Rich Maciejewski. Courtesy of the John Michael Kohler Arts Center and Kohler Co.

24. Photo William H. Bengtson. Collection David Katz, San Francisco, CA.

25. Photo William H. Bengtson.

26. Photo William H. Bengtson.

28. Photo William H. Bengtson.

29. Photo William H. Bengtson. Collection of Marilyn Laufer and Tom Butler, Columbus, GA.

30. Photo William H. Bengtson. Collection of Nell and Paul Schneider, Chicago. IL.

31. Photo William H. Bengtson. Indiana University Museum of Art. Gift of Deborah and Stephen Mueller in memory of his parents Karl and Tammy Mueller.

32. Photo William H. Bengtson.

33. Photo William H. Bengtson.

34 and 35. Photo John Spence. Collection Marc and Kathy LeBaron, Lincoln, NE.

36. Photo William H. Bengtson.

37. Photo William H. Bengtson.
Collection of Charles and Elizabeth Sklarsky, Chicago, IL.

38 and 39. Photo Christine Himmelfarb. Collection Karen and Robert Duncan, Lincoln, NE.

40. Photo Logan Roots, Modern Arts Midtown.

41. Photo William H. Bengtson.

42. Photo William H. Bengtson.

43. Photo William H. Bengtson. Published by The Herron School of Art print department.

44. Installation for Indianapolis Downtown Artists and Dealers Association in conjunction with Super Bowl 2012. Photo Mark Ruschman.

45 and 46. Photo and published by www.stewartstewart.com

47. Photo William H. Bengtson.

48. Photo William H. Bengtson.

49. Photo William H. Bengtson.

50. Photo William H. Bengtson.

51. Photo William H. Bengtson.

52. Photo William H. Bengtson.

53. Photo Logan Roots. Courtesy Modern Arts Midtown. Collection Mollie and Terry Foster, Omaha, NE.

54. Photo Logan Roots. Courtesy Modern Arts Midtown. Collection Mollie and Terry Foster, Omaha, NE.

55. Photo William H. Bengtson.

56. Photo William H. Bengtson.

57. Photo William H. Bengtson.

58. Photo William H. Bengtson. The Alagarto Printmaking Press, University of Florida School of Art and Art History.

59. Photo William H. Bengtson.

60. Photo William H. Bengtson.

61 and 62. Photo William H. Bengtson. Courtesy Taller de Gráfica del Antiguo Colegio Jesuita de Patzcuaro, Michoacán.

63. Photo William H. Bengtson.

64. Photo William H. Bengtson. Katz Family Collection.

65. Photo William H. Bengtson.
Collection Bryan Cave LLP, Chicago, IL.

66. Photo William H. Bengtson.

67. Photo William H. Bengtson.

68. Photo William H. Bengtson.

69. Photo William H. Bengtson.

70. Photo William H. Bengtson.

71. Photo William H. Bengtson.
Private Collection.

72. Photo William H. Bengtson.

73. Photo William H. Bengtson.

74. Photo William H. Bengtson.

75. Photo William H. Bengtson. Collection of the Jule Collins Smith Museum of Fine Art, Auburn

University, museum purchase with funds given by Joyce and Roger Lethander in memory of his parents, Walter and Mildred Lethander.

76-91 Photos William H. Bengtson.

92. Photo William H. Bengtson.

93 and 94. Photo William H. Bengtson.

95. Katz Family Collection, Tiburon, CA. Photo Rich Maciejewski. Courtesy of the John Michael Kohler Arts Center and Kohler Co.

96. Photo William H. Bengtson. Katz Family Collection.

97. Photo William H. Bengtson.

98. Photo Michael Hoefle.

99. Photo William H. Bengtson. Collections of Gary and Susan Mostow, Chicago, IL; Timothy Thurlow and Kenneth East, Chicago.

100. Photo Rich Maciejewski. Courtesy of the John Michael Kohler Arts Center and Kohler Co.

101. Photo William H. Bengtson.

102. Photo William H. Bengtson.

103. Photo Rich Maciejewski. Courtesy of the John Michael Kohler Arts Center and Kohler Co.

104. Photo William H. Bengtson.

First Edition

© 2014 The Artist Book Foundation

All Art and Photography © John Himmelfarb

Published in the United States by The Artist Book Foundation
115 East 57th Street, 11th floor, New York, New York 10022

Distributed in the United States, its territories and possessions, and Canada by
ARTBOOK LLC D.A.P.| Distributed Art Publishers, Inc.
www.artbook.com
Distributed outside North America by ACC Distribution
www.accdistribution.com/uk

Publisher and Co-founder: Leslie Pell van Breen
Co-founder: H. Gibbs Taylor, Jr.

Production Manager: David Skolkin
Project Editor: Mary Wachs
Design: David Skolkin

Printed and bound through Asia Pacific Offset
Manufactured in China

Library of Congress Control Number: 2013948576
ISBN: 978-0-9888557-3-1.

Cover: Detail of *Penelope Awaiting Her Chamberlain*, 2013